ERNST HAECKEL

Art Forms in Nature

COLORING BOOK

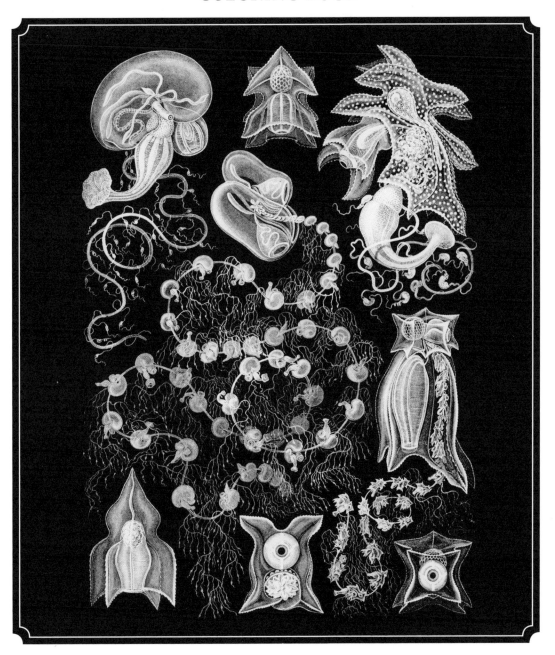

Pomegranate

PORTLAND, OREGON

Pomegranate Communications, Inc.
19018 NE Portal Way, Portland OR 97230
800 227 1428; www.pomegranate.com

Pomegranate Europe Ltd.
Unit 1, Heathcote Business Centre, Hurlbutt Road
Warwick, Warwickshire CV34 6TD, UK
[+44] 0 1926 430111; sales@pomeurope.co.uk

Item No. CBK003

Front cover:
Ernst Haeckel (German, 1834–1919)
Ascidiae – Seescheiden, from *Kunstformen der Natur*
(Leipzig and Vienna: Bibliographisches Institut, 1904), plate 85
Prints and Photographs Division, Library of Congress

Cover design by Stephanie Odeh

Printed in China

25 24 23 22 21 20 19 18 17 16 10 9 8 7 6 5 4 3

KUNSTFORMEN *der Natur*, or *Art Forms in Nature*, encapsulates biologist Ernst Haeckel's response to Charles Darwin's *On the Origin of Species*. Haeckel (German, 1834–1919) published these exquisitely rendered depictions of flora and fauna in ten installments of ten illustrations from 1899 to 1904, aiming to widen the general public's understanding of naturalism. Haeckel also clearly saw his illustrations as more than just scientific documentation: in introducing one of his plates, he wrote that its patterns would not be out of place in embroideries or on urns and bottles. Haeckel's elaborate forms have been called a precursor to art nouveau, and his influence even stretched to architecture.

These illustrations derive from a copy of *Kunstformen der Natur* in the Case Book Collection in the Prints and Photographs Division of the Library of Congress. The Library holds over 160 million items in almost all media and in more than 470 languages.

THE oldest federal cultural institution in the United States and the largest library in the world, the Library of Congress holds over 160 million items in almost all media and in more than 470 languages. Included among the more than 15 million items in the Library's Prints and Photographs Division is a copy of German biologist Ernst Haeckel's *Kunstformen der Natur* (1904), filled with exquisitely rendered depictions of flora and fauna. It is one of more than 2,200 items in the division's Case Book Collection, so called because the volumes within it were originally retrieved from the Library's general book collections and placed in special bookcases within the division. Spanning almost five centuries, these Case Books vary widely in subject matter and country of origin, but each volume is filled with a wealth of visual information. The catalog of Case Book holdings is available online at loc.gov/pictures/collection/casebk/.

THE images in this coloring book are based on illustrations from *Kunstformen der Natur* (Leipzig and Vienna: Bibliographisches Institut, 1904) by Ernst Haeckel (German, 1834–1919).

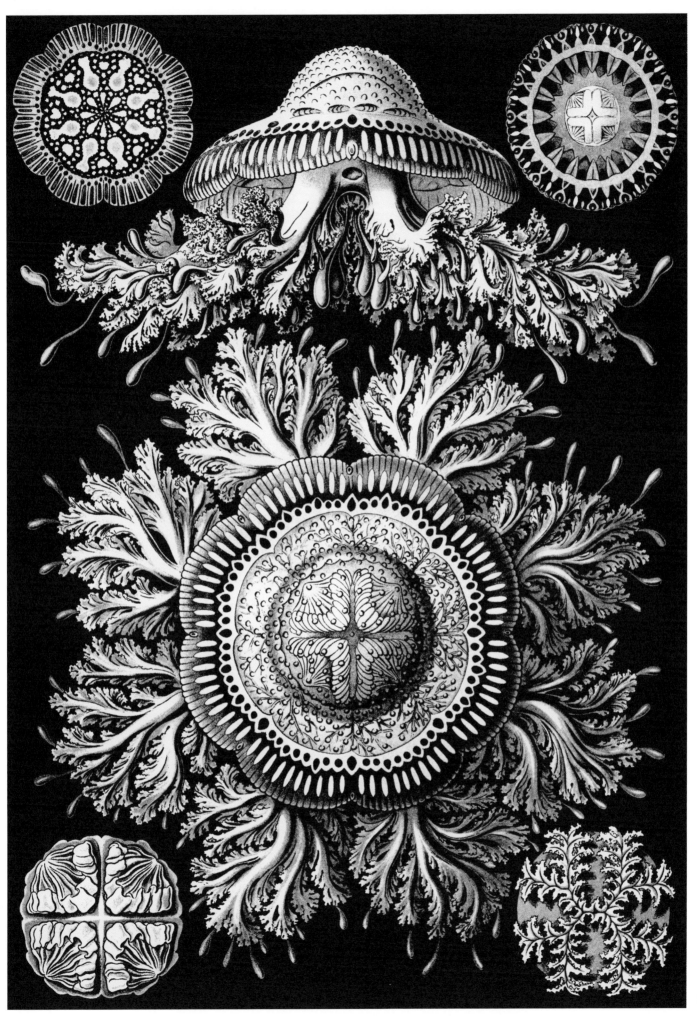

1

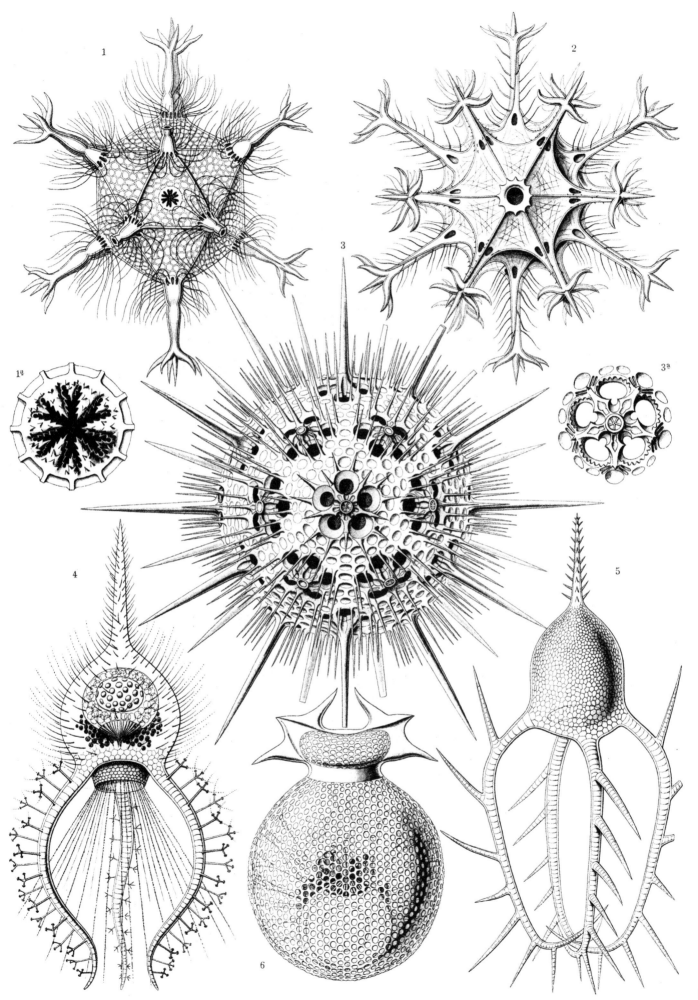

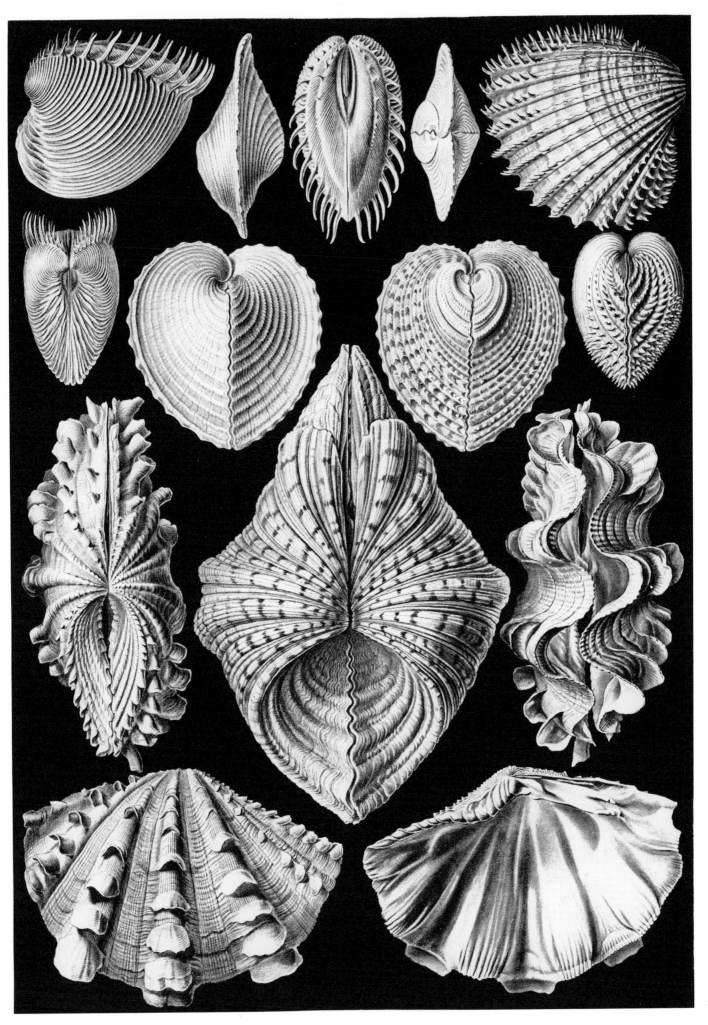

3

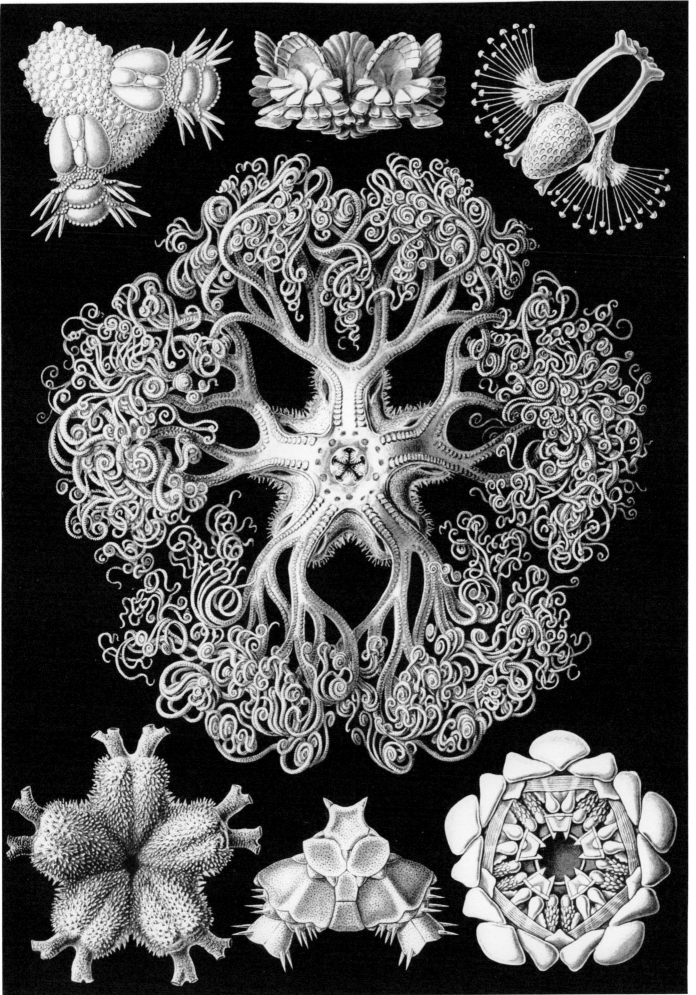

4

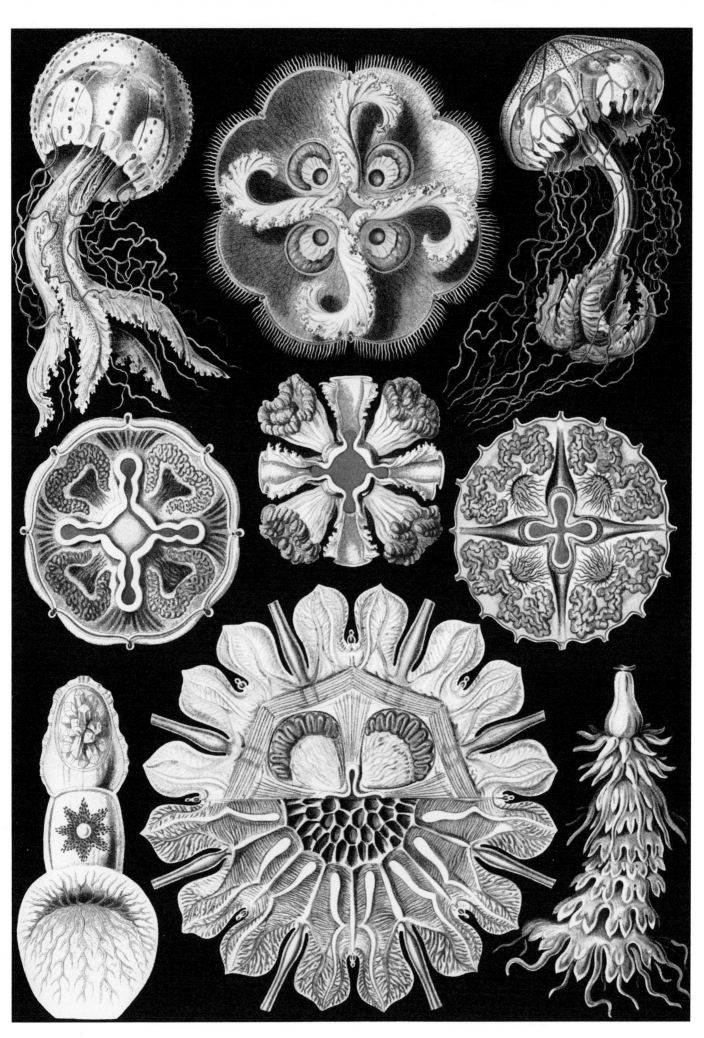

5

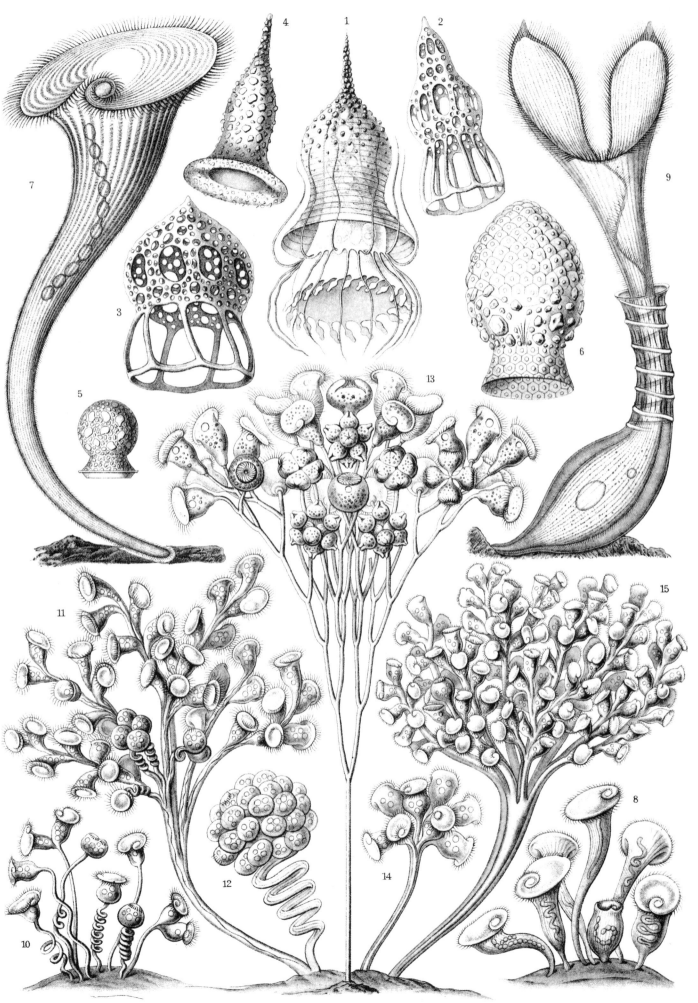

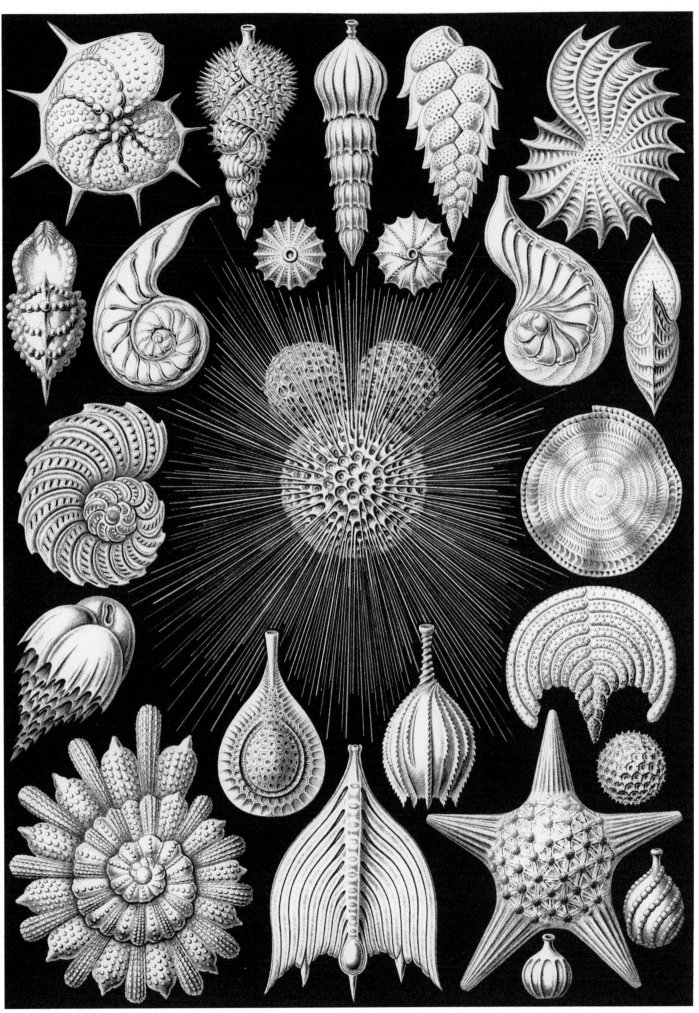

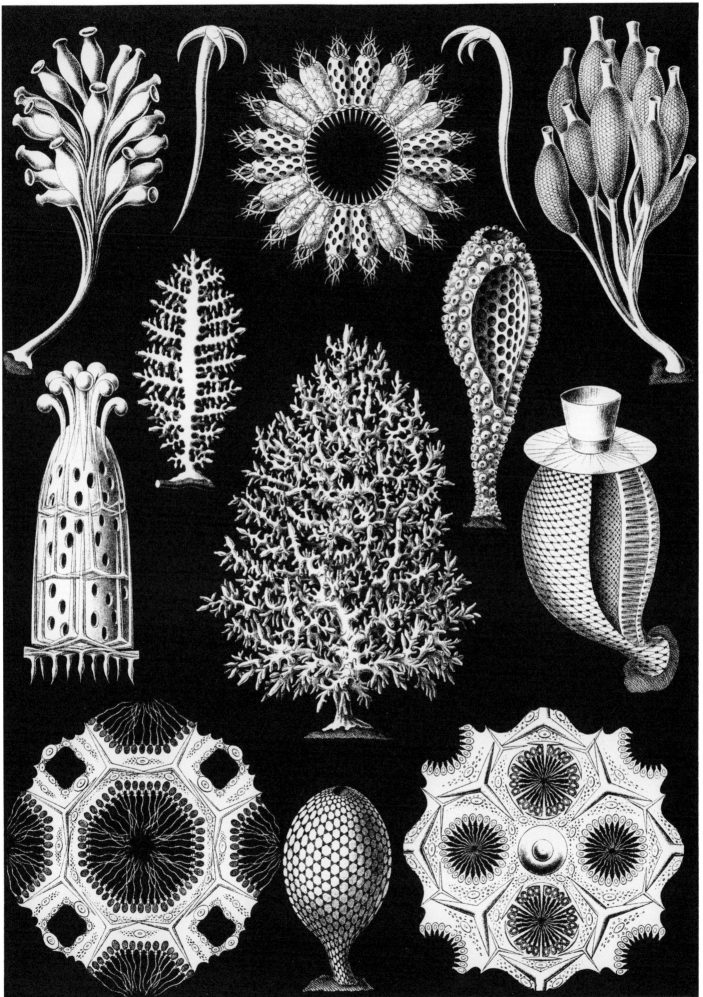

8

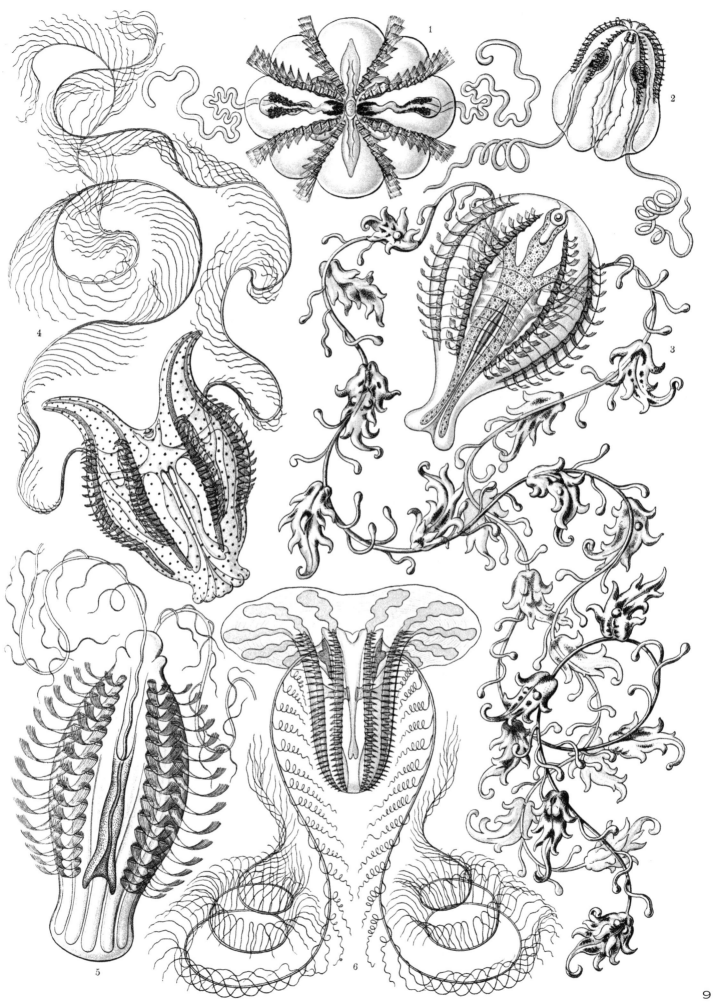

9

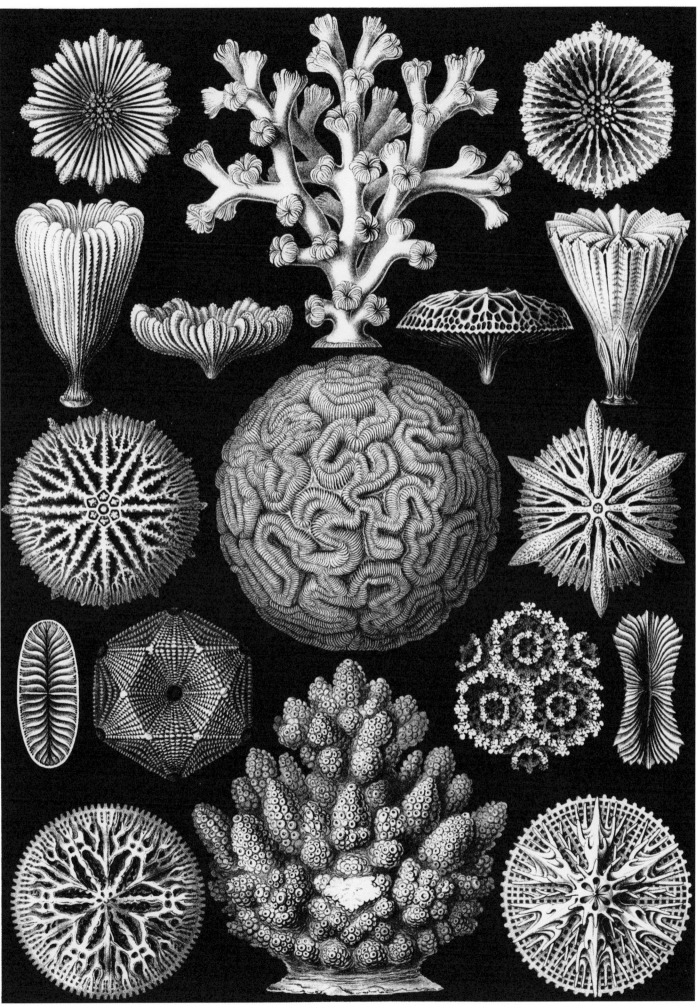

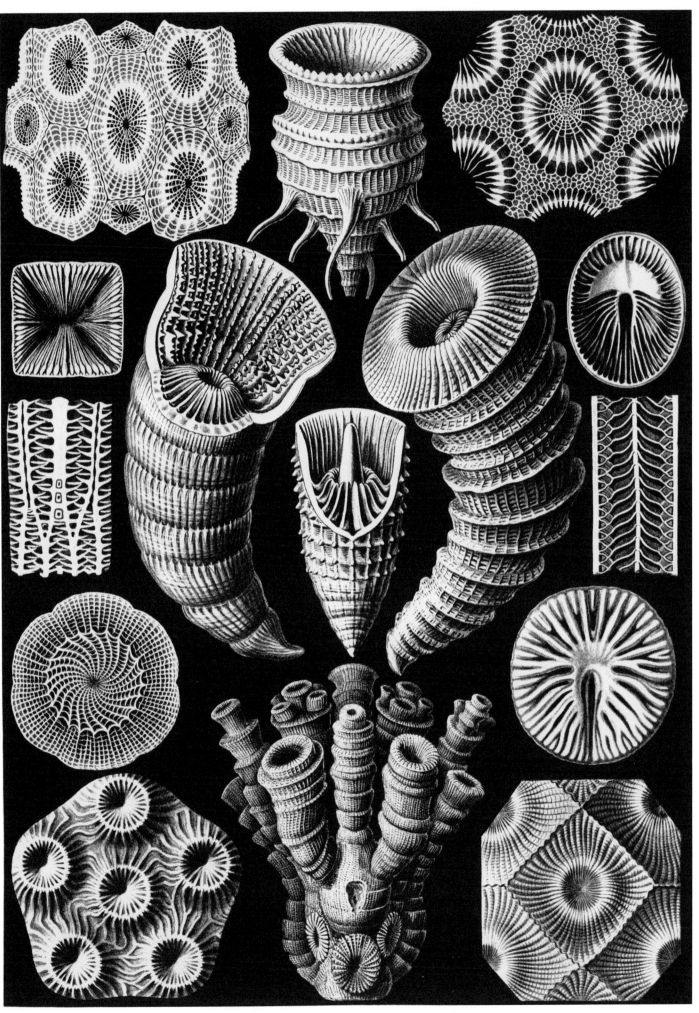

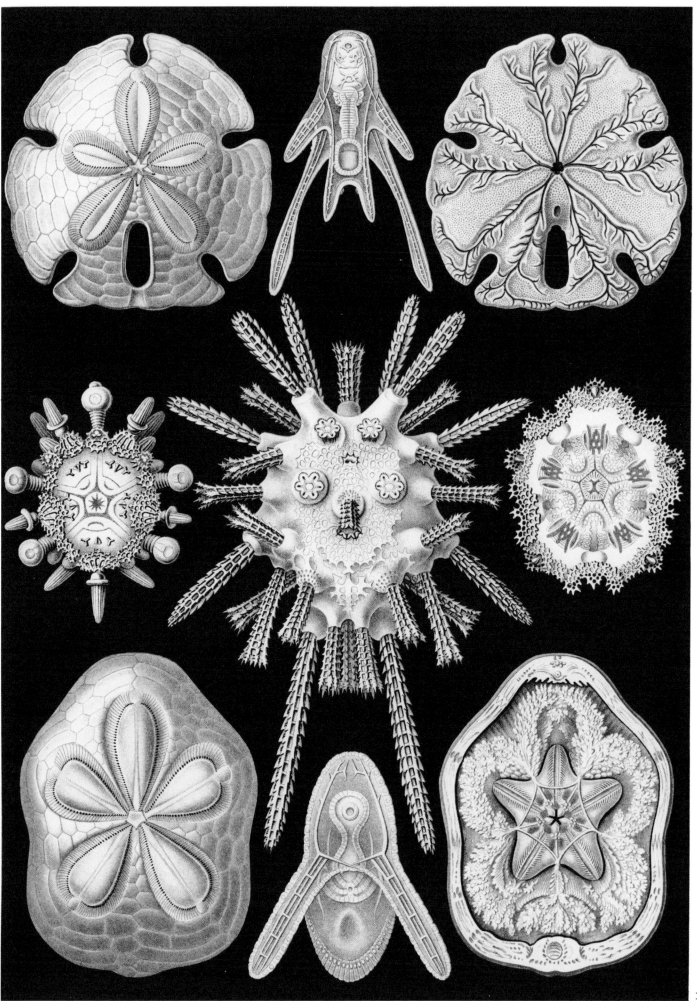

12

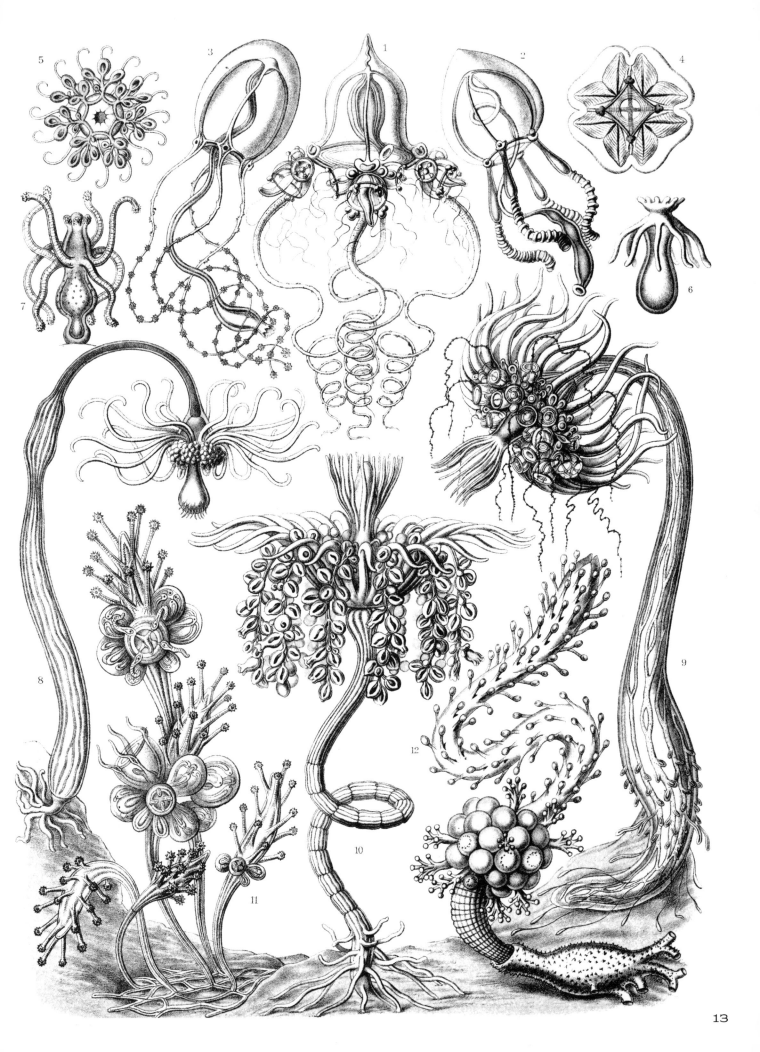

13

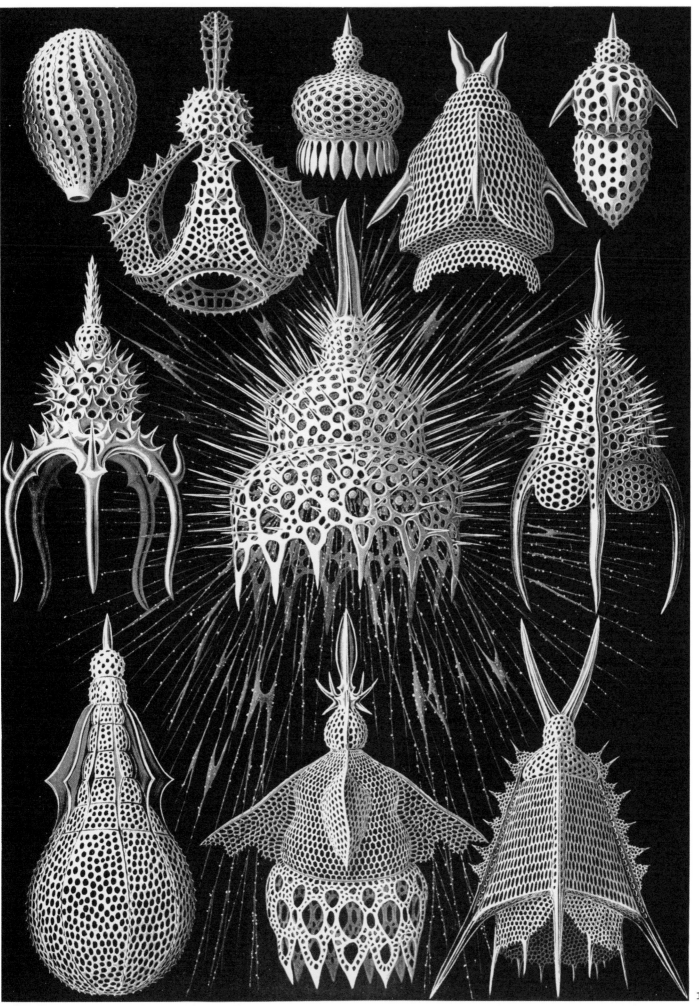

14

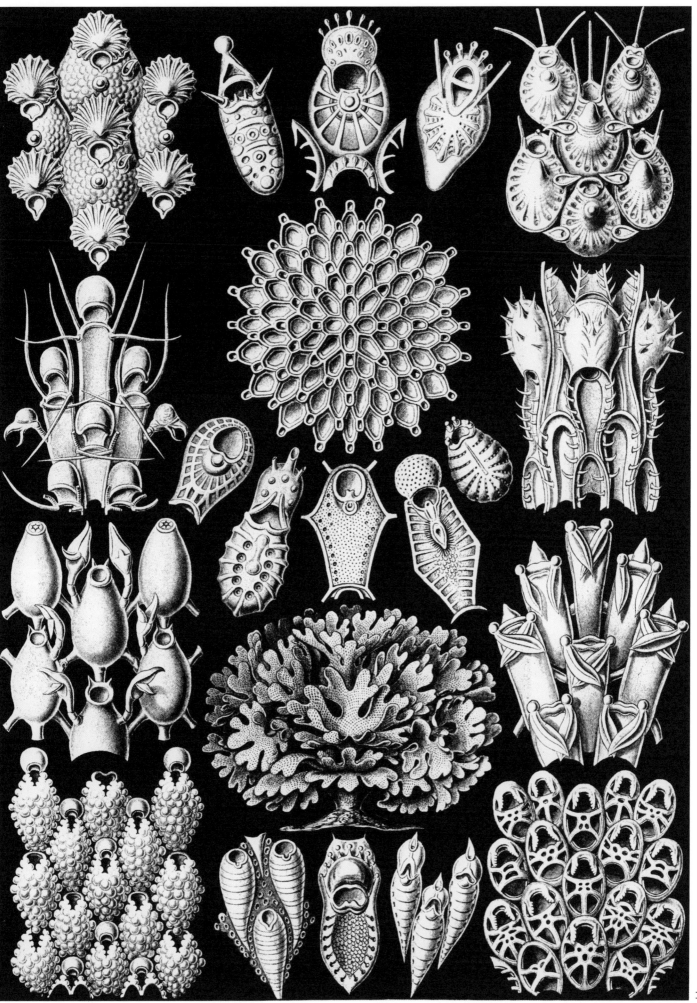

15

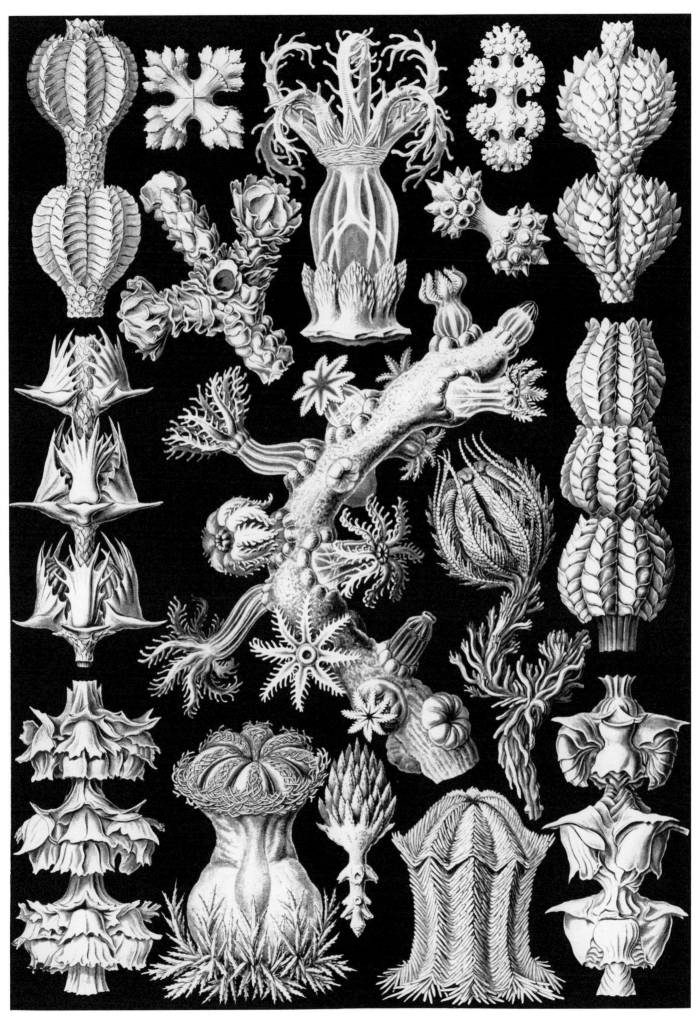

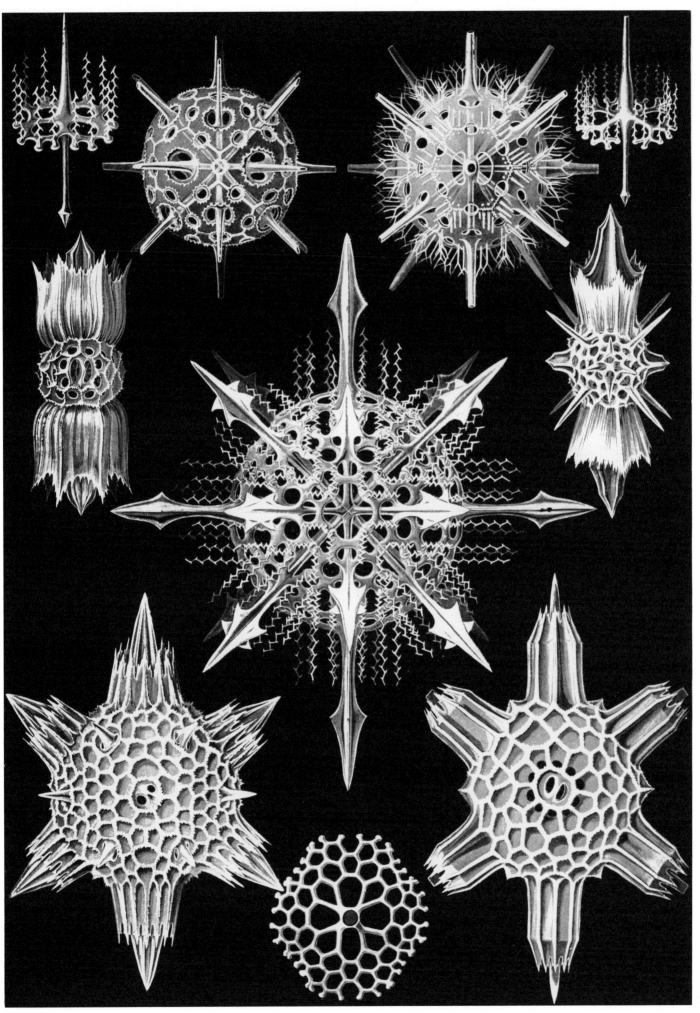

17

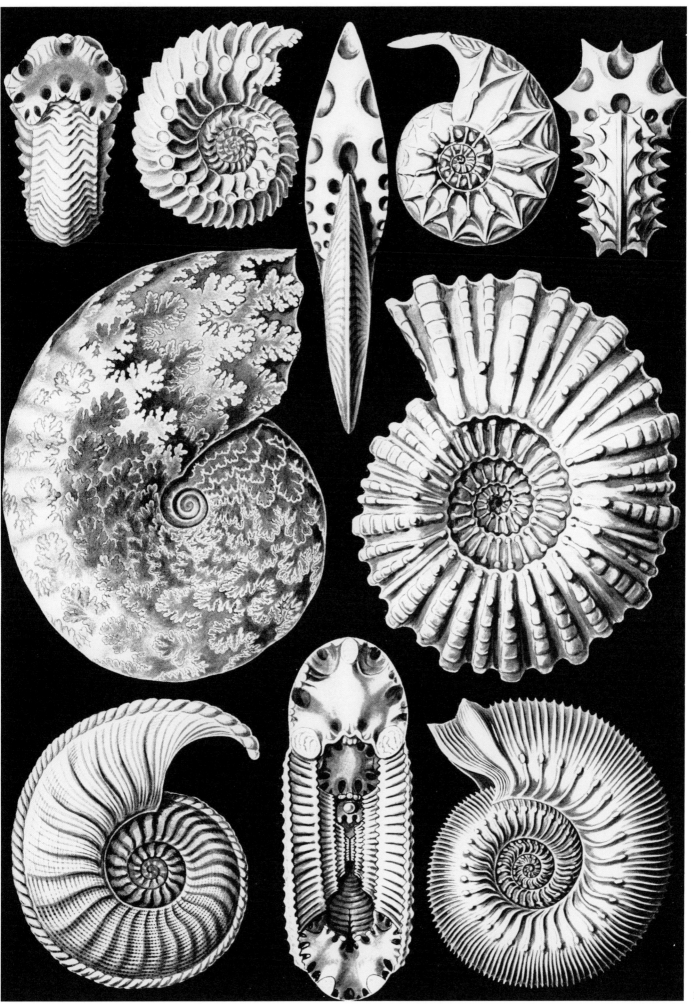

18

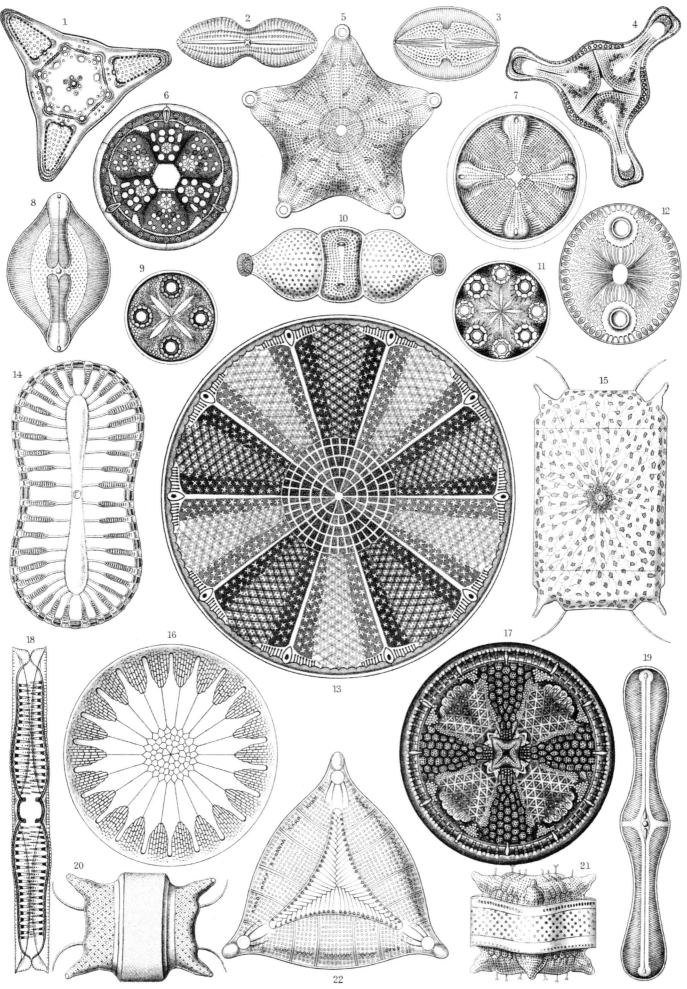

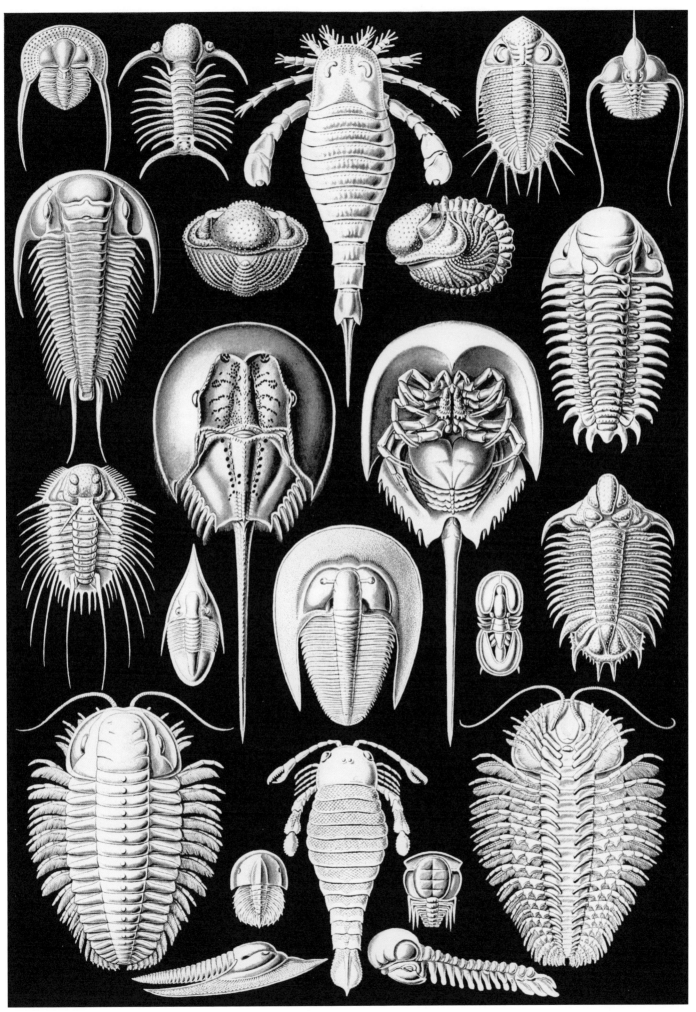

20

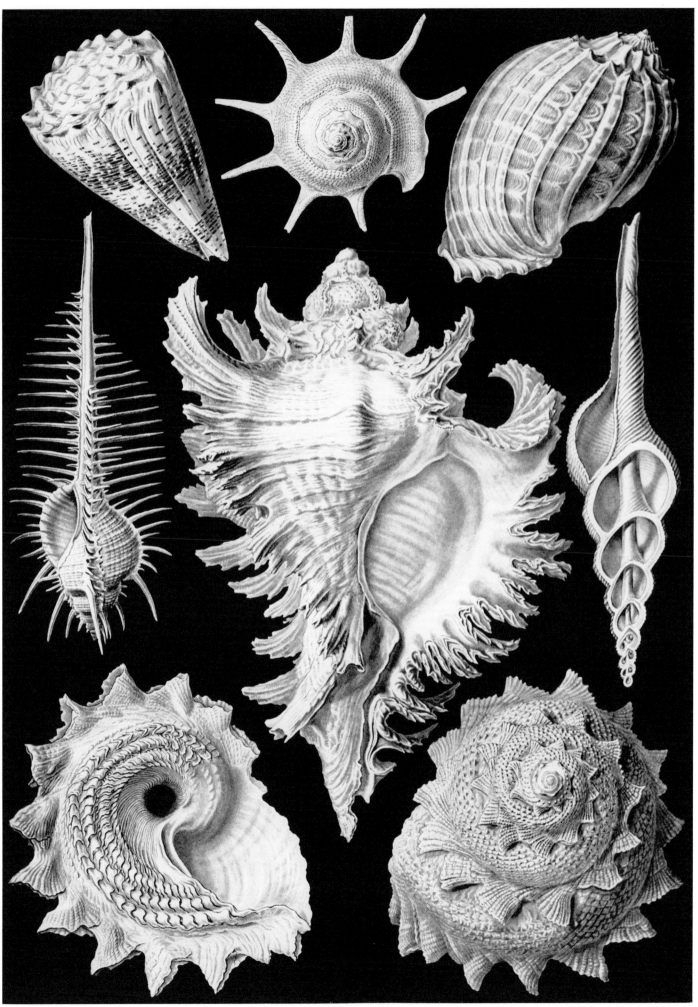

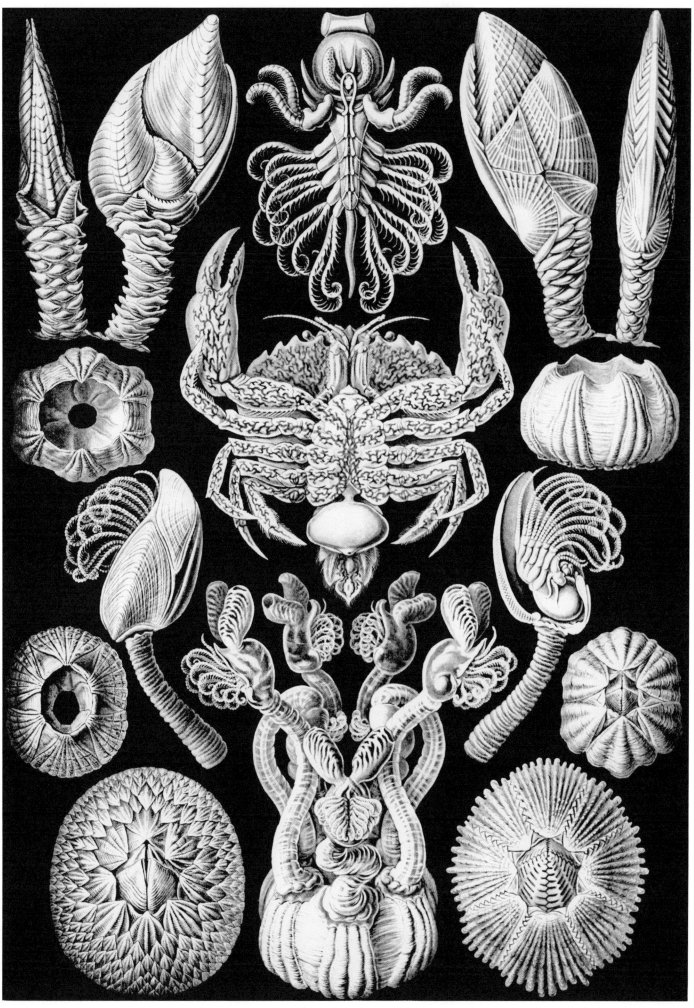

22

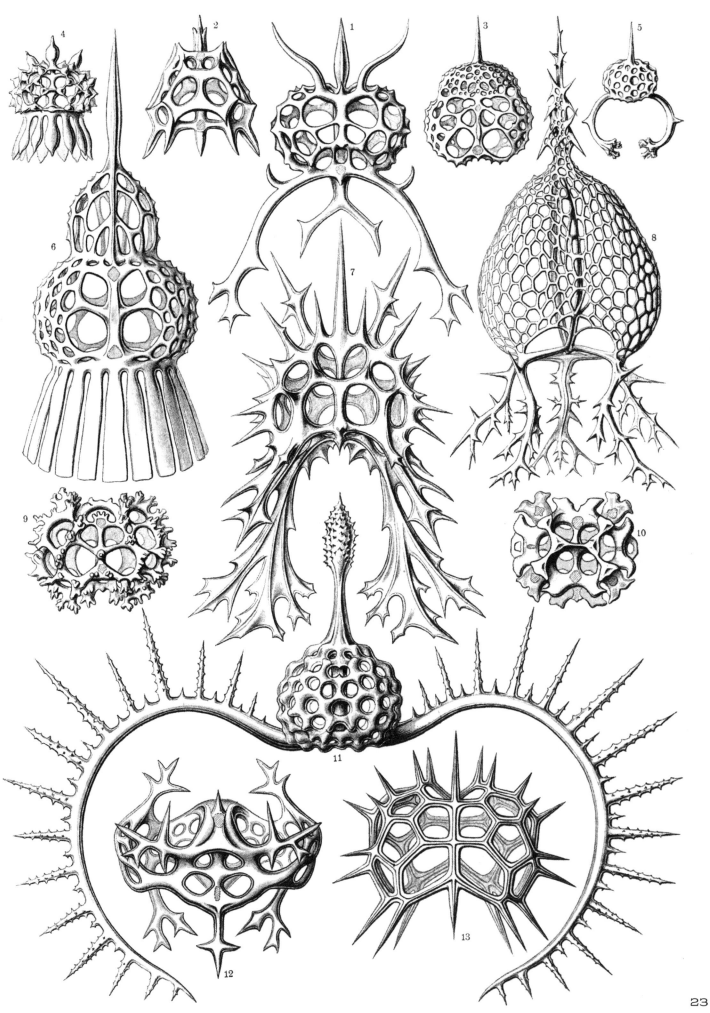

23

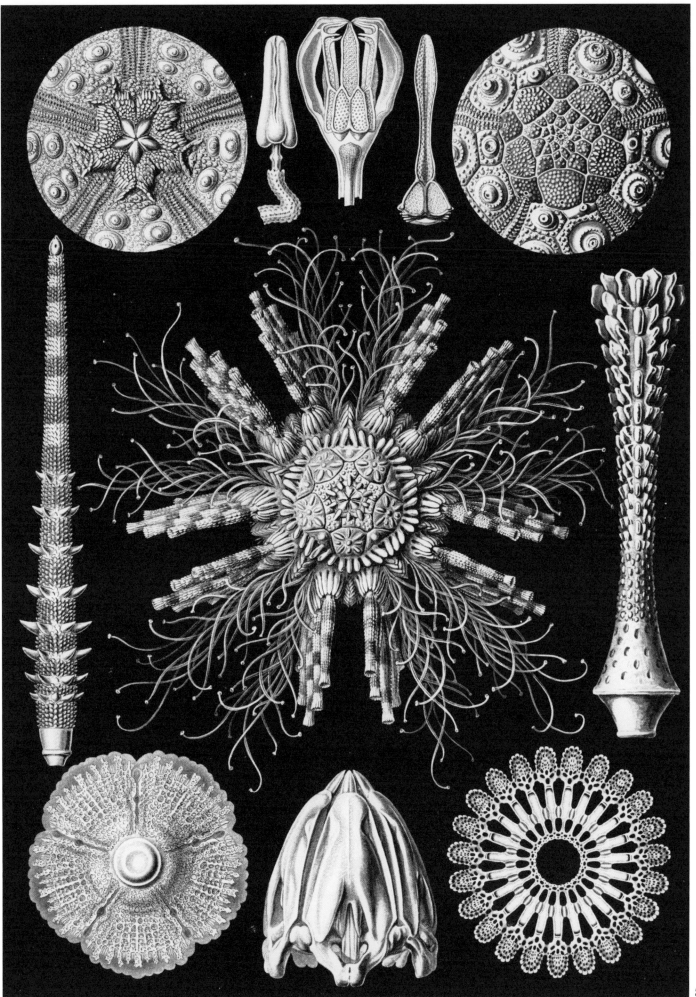

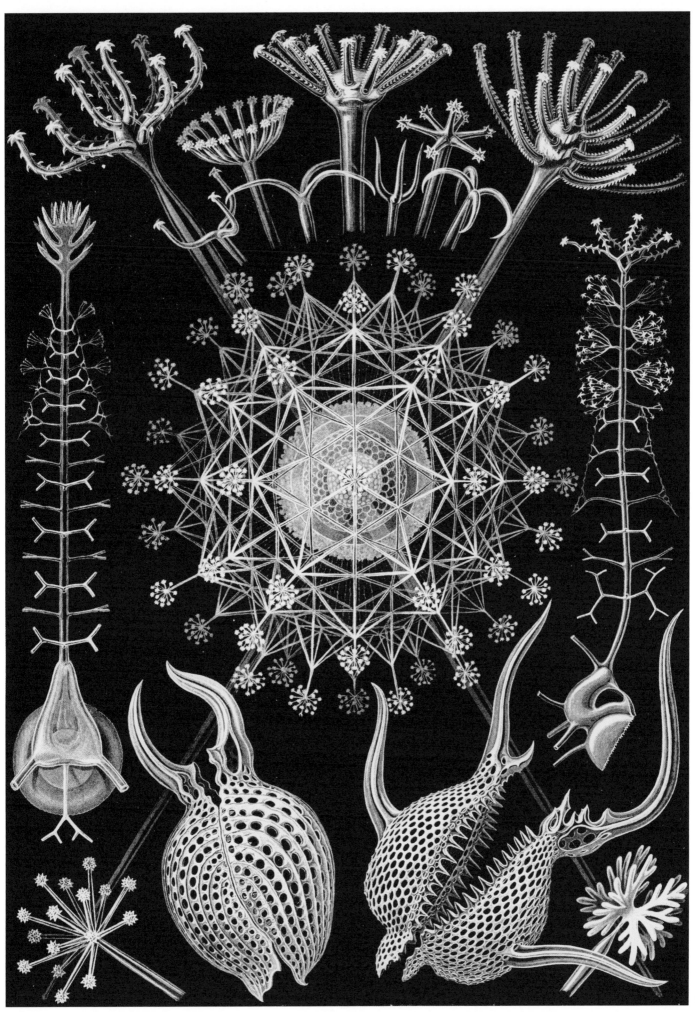

25

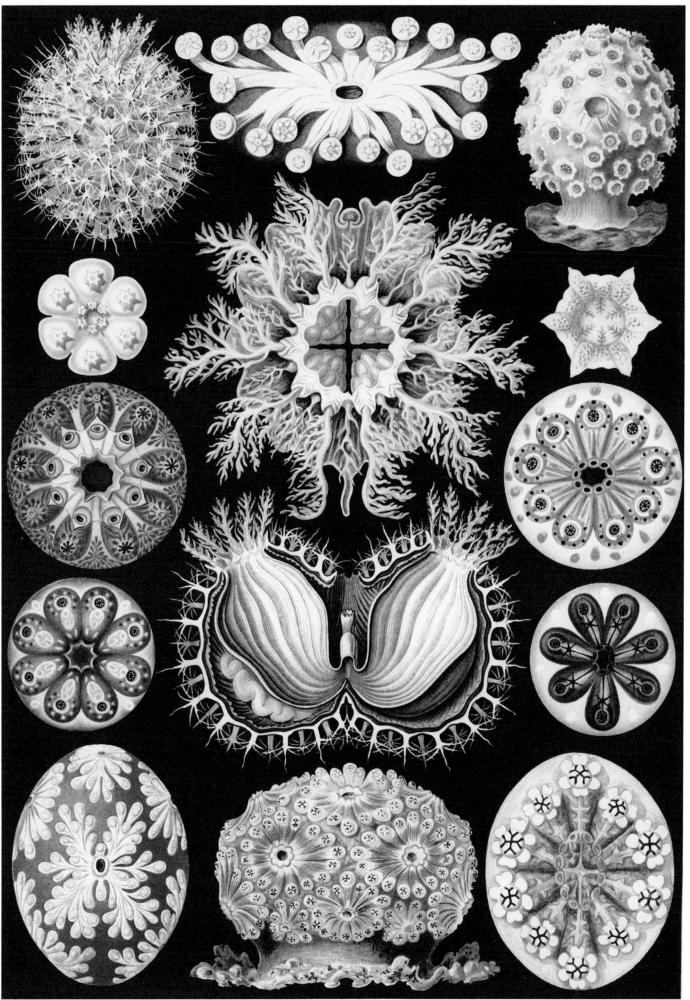

26

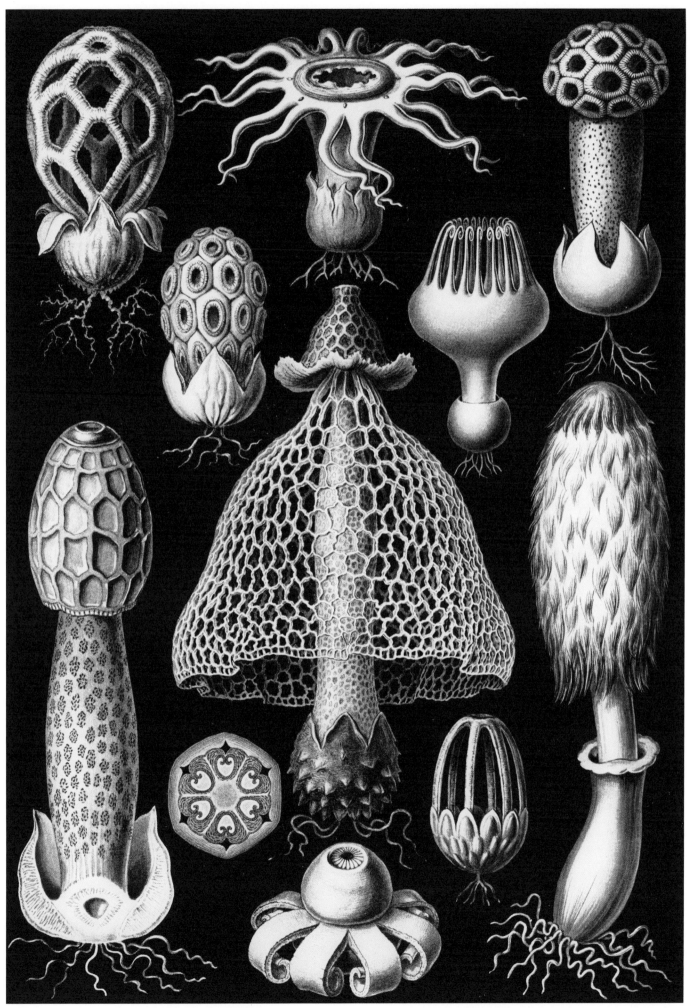

27

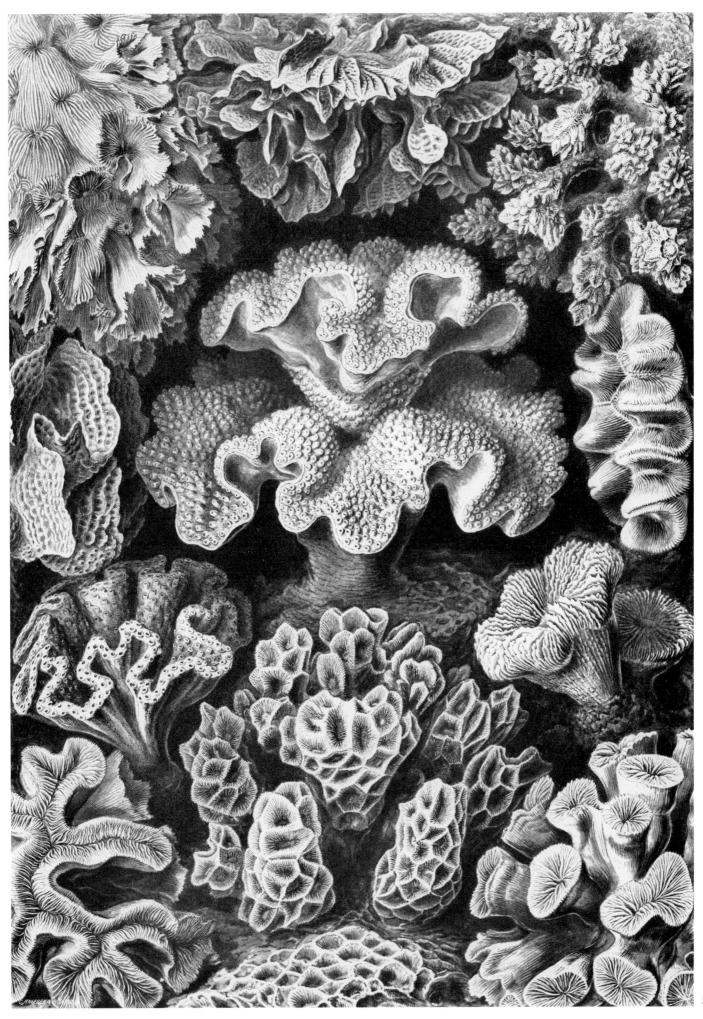

28

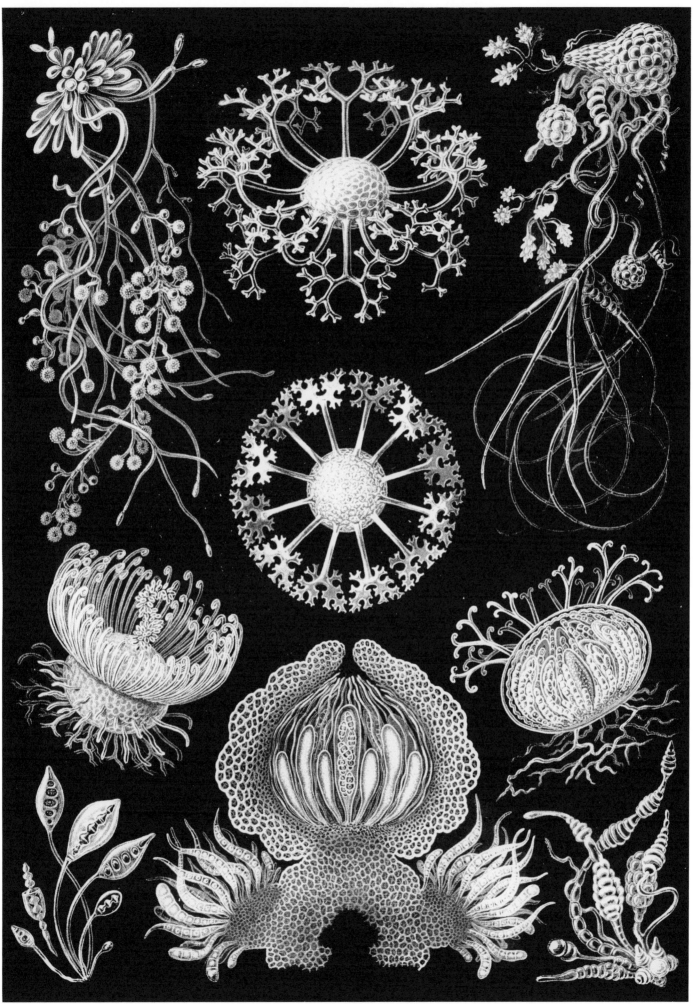

29

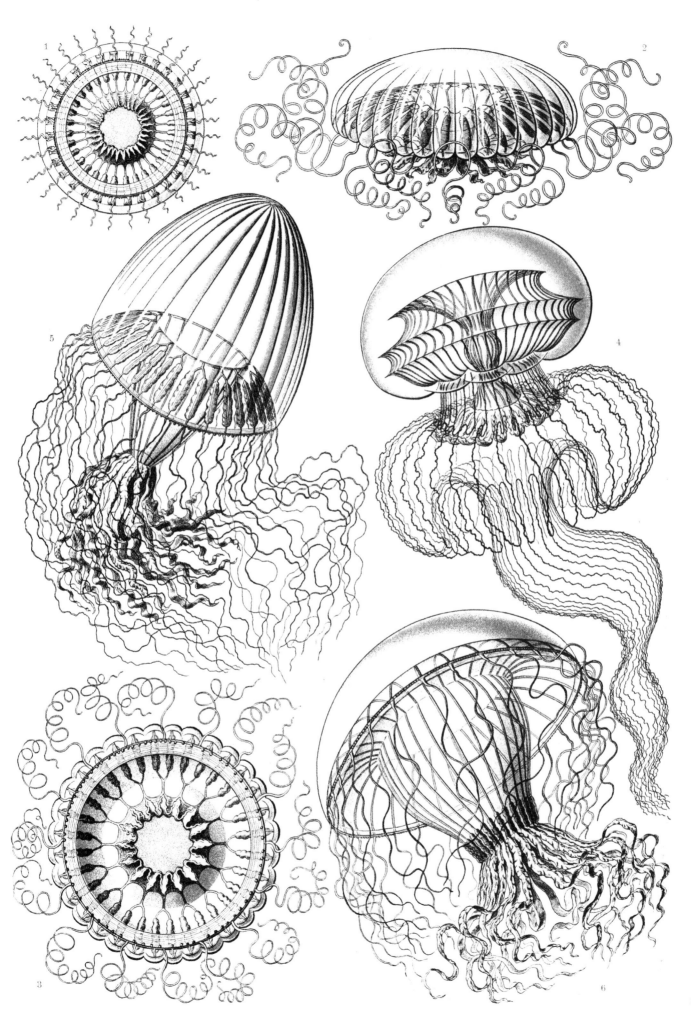

30

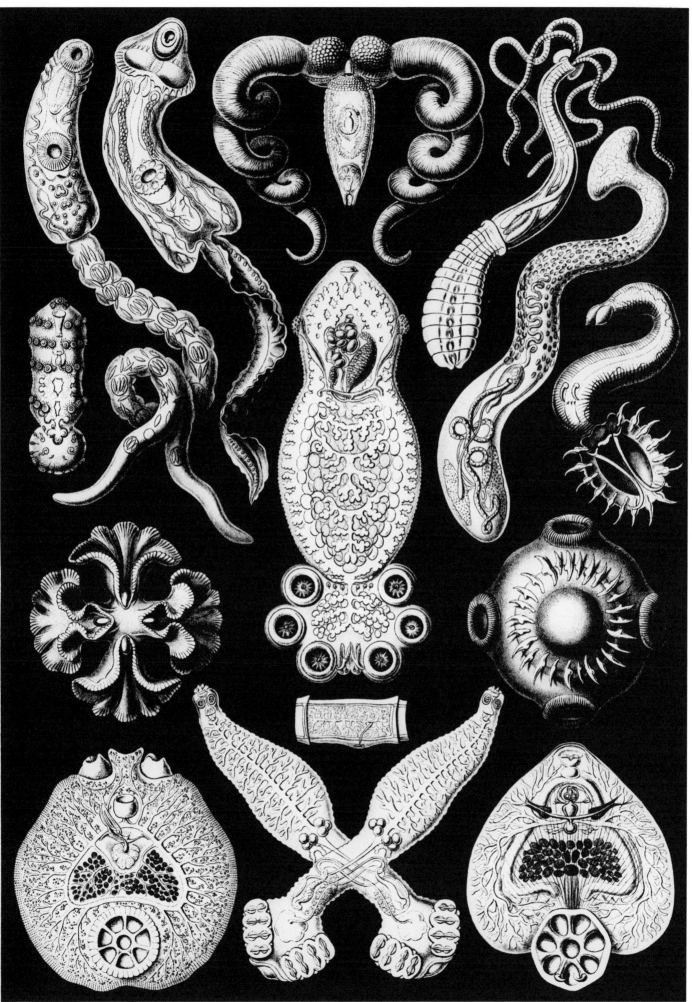

31

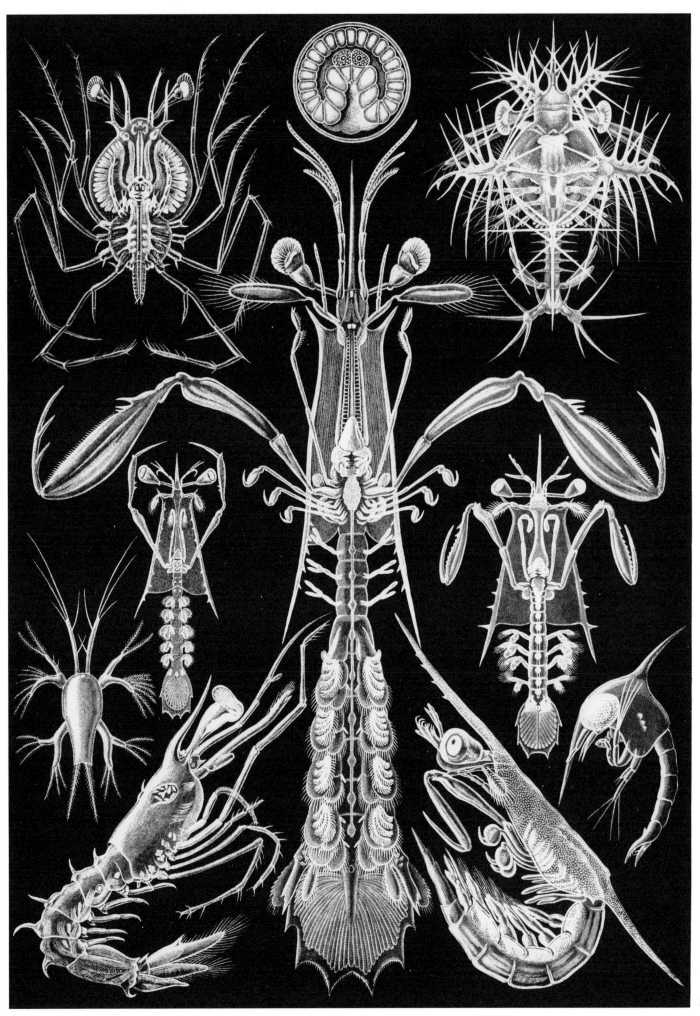

32

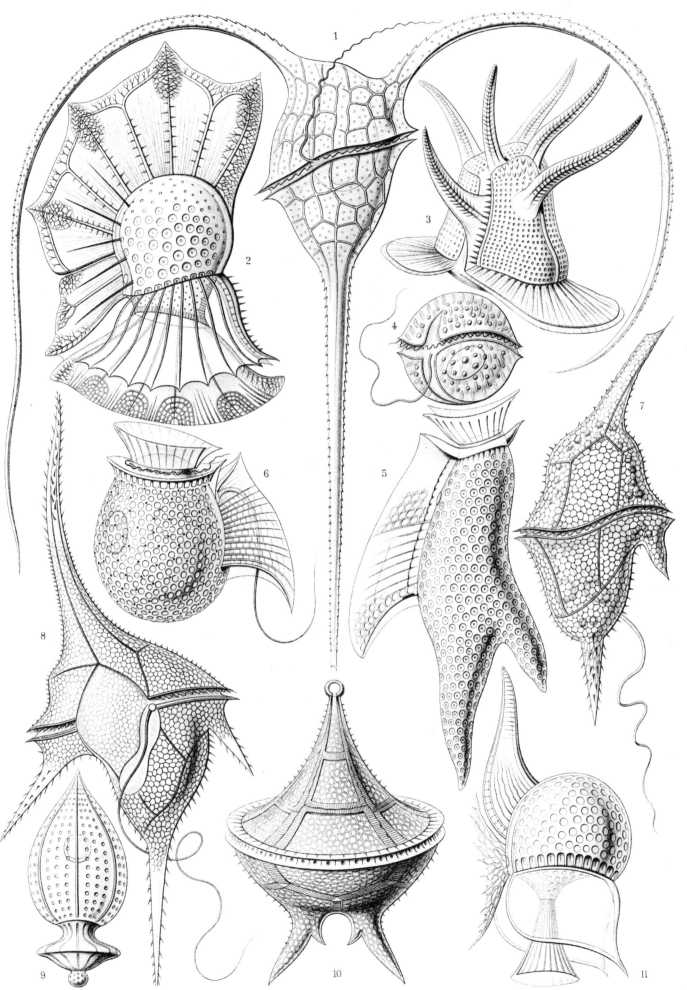

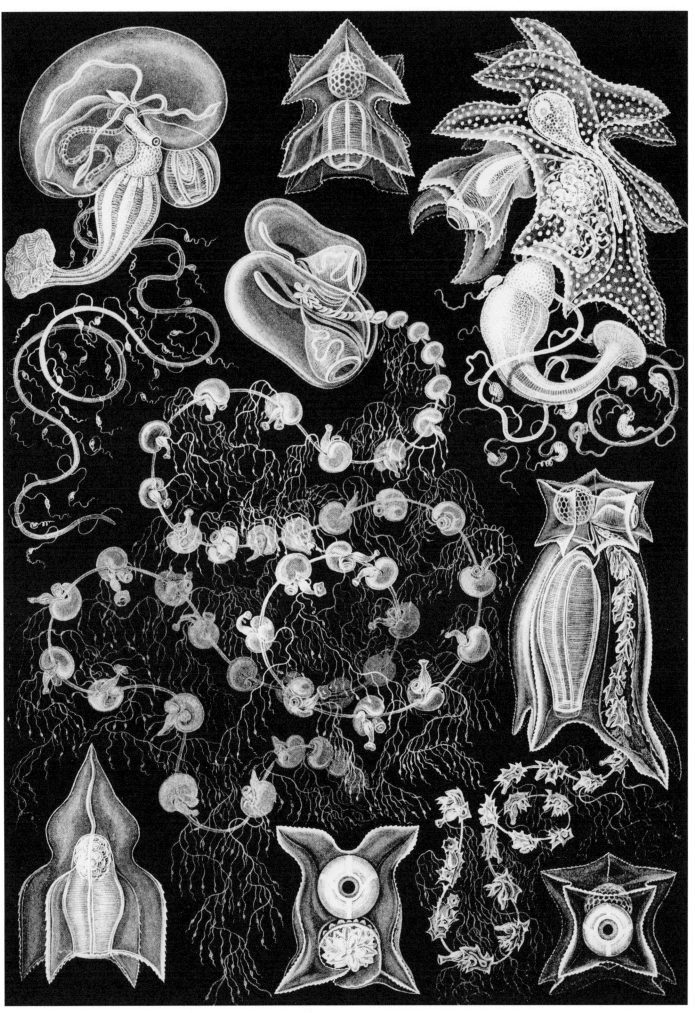

34

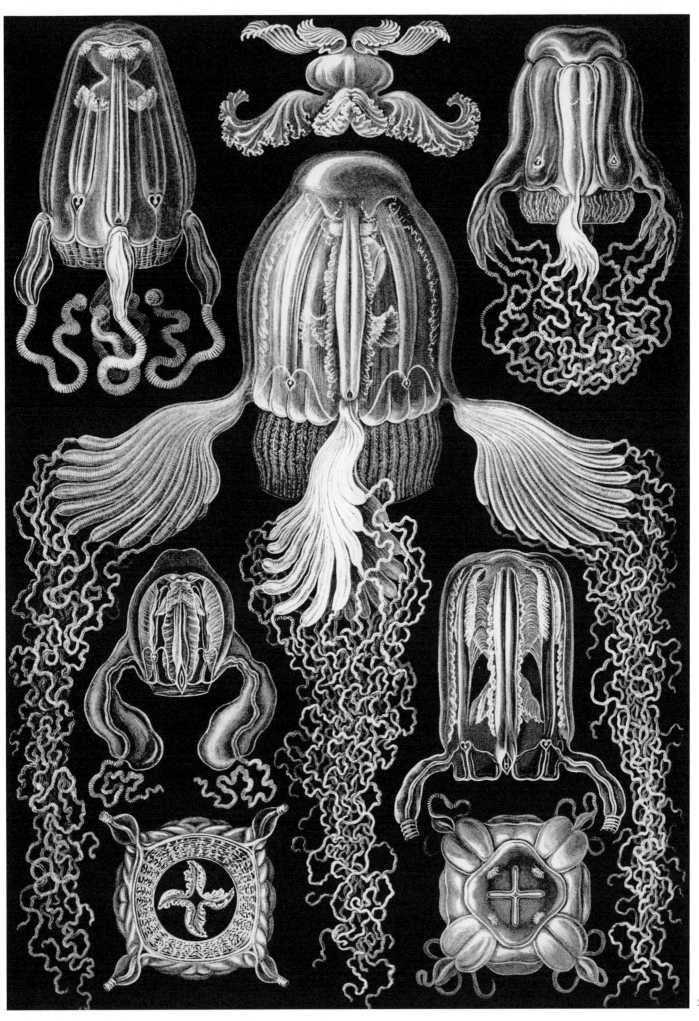

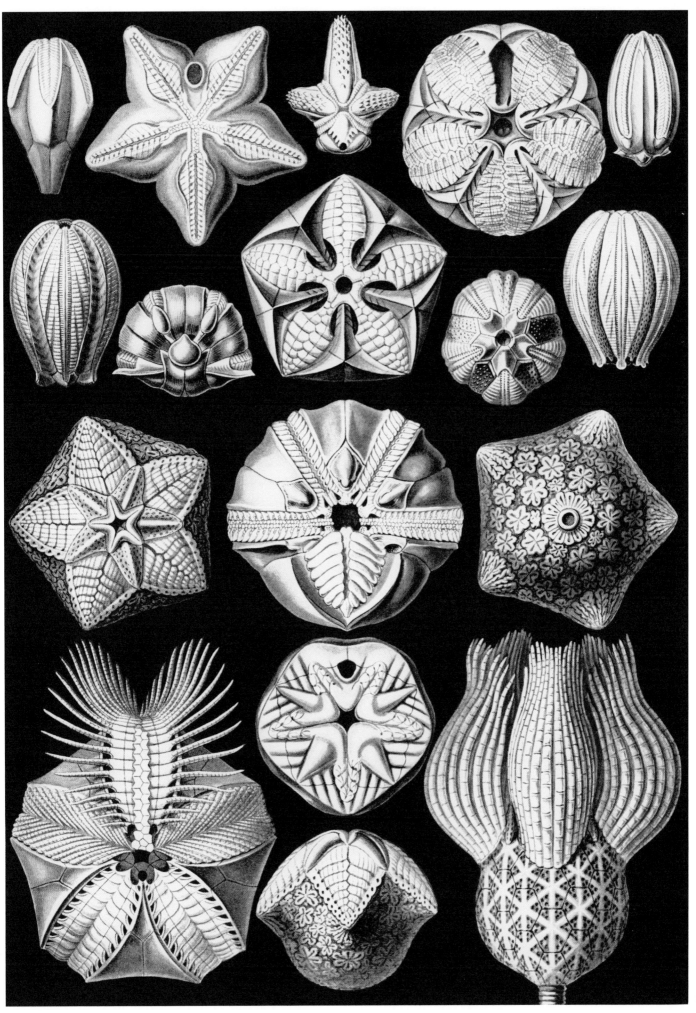

36

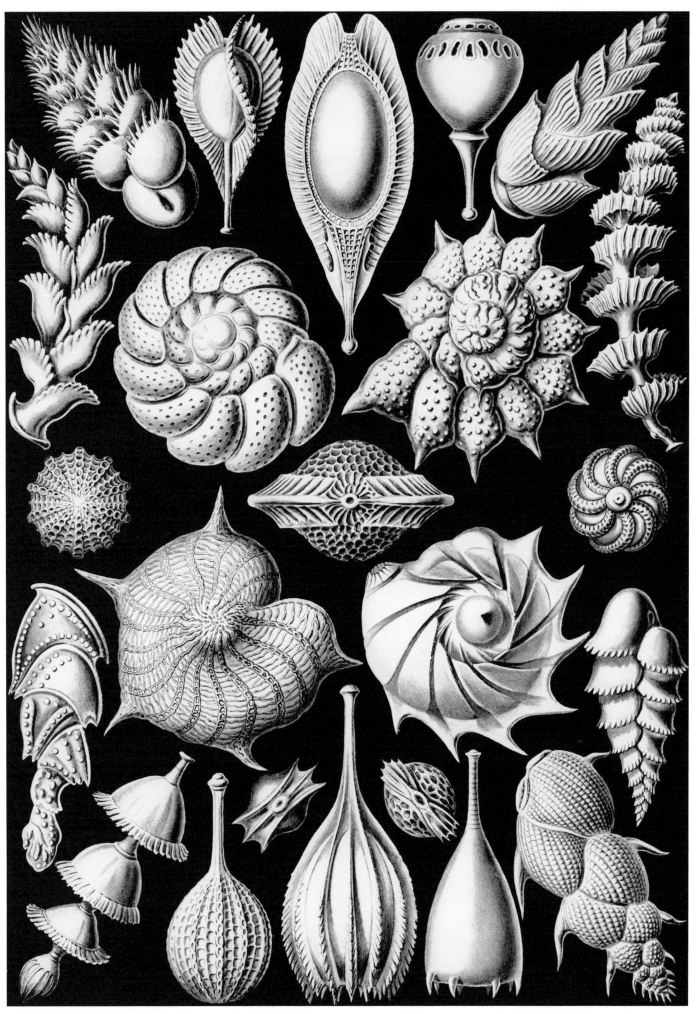

37

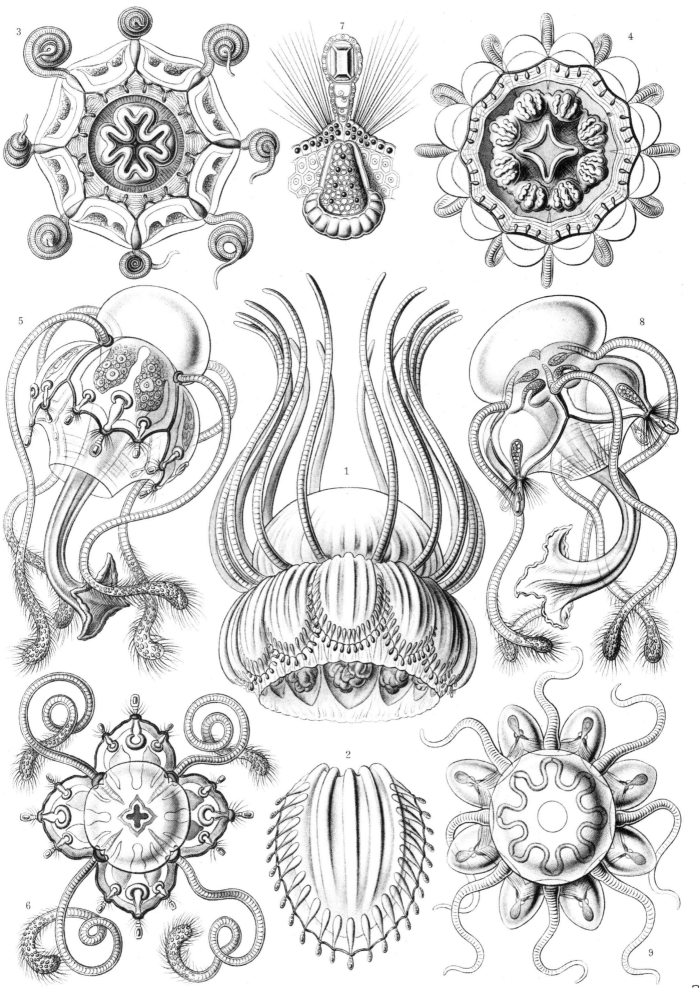

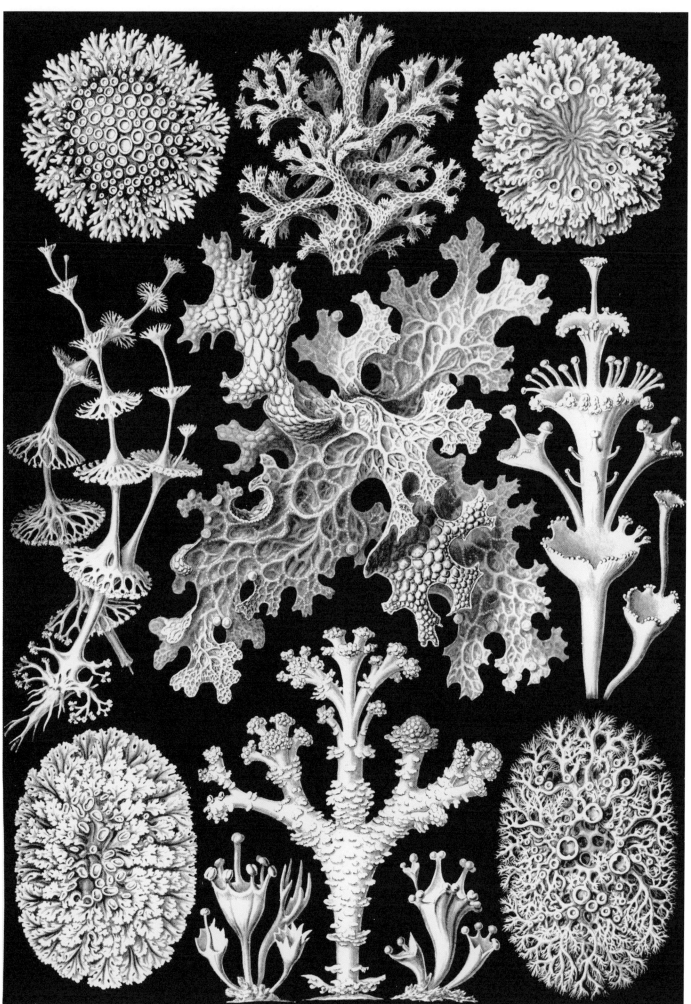

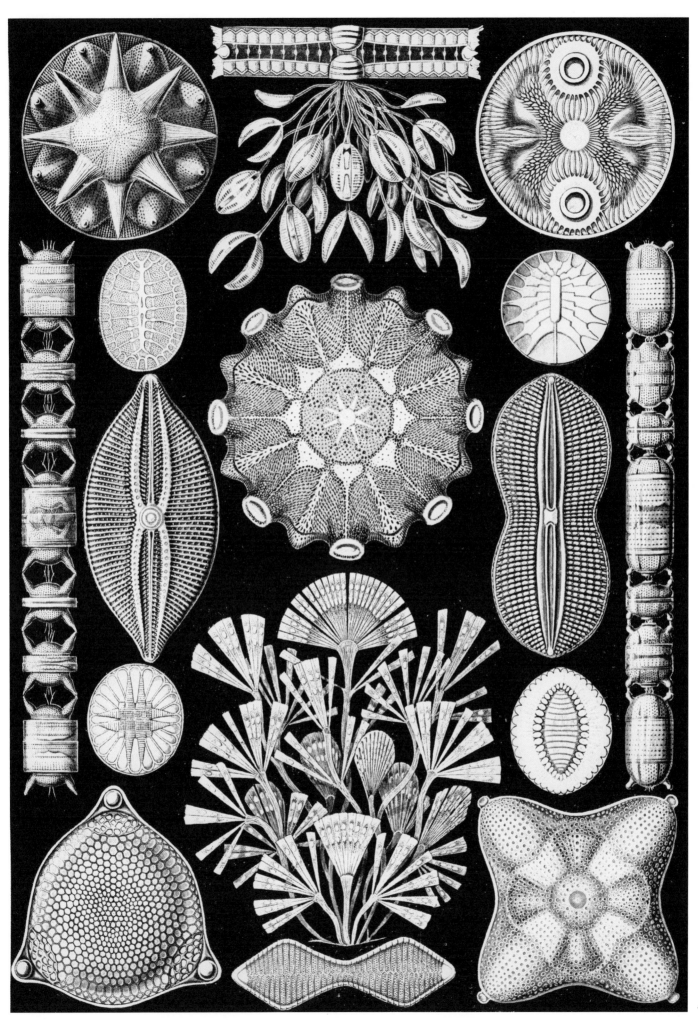

40

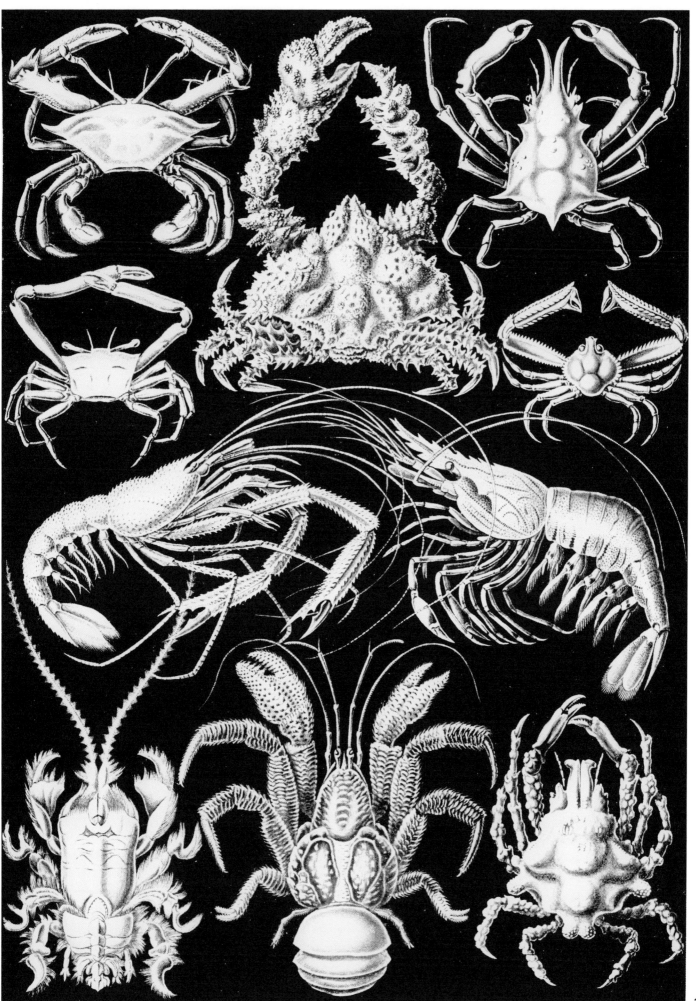

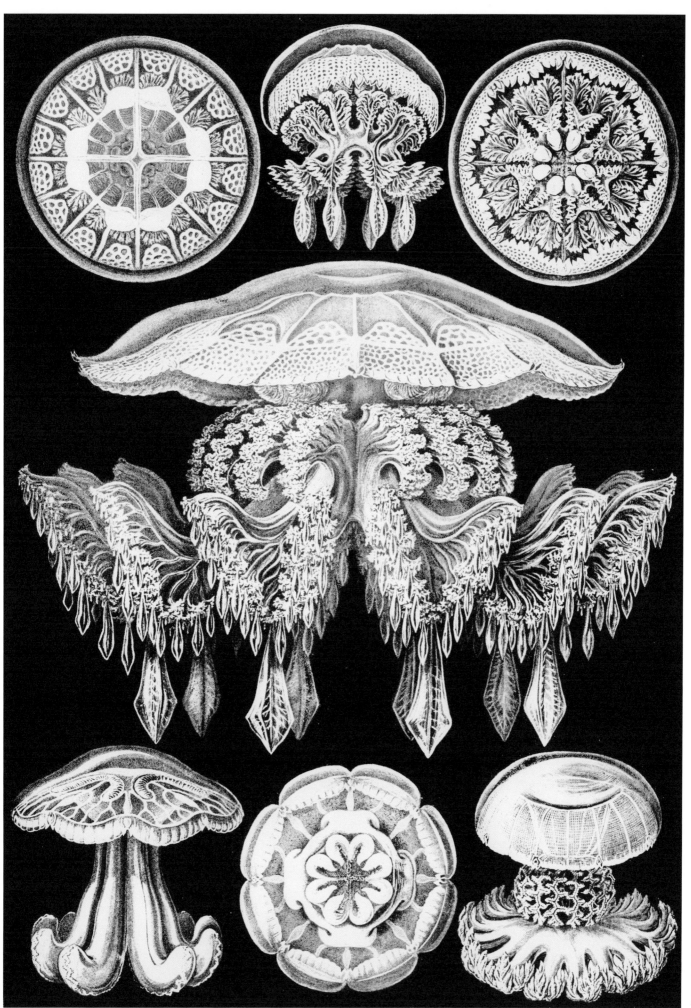

42

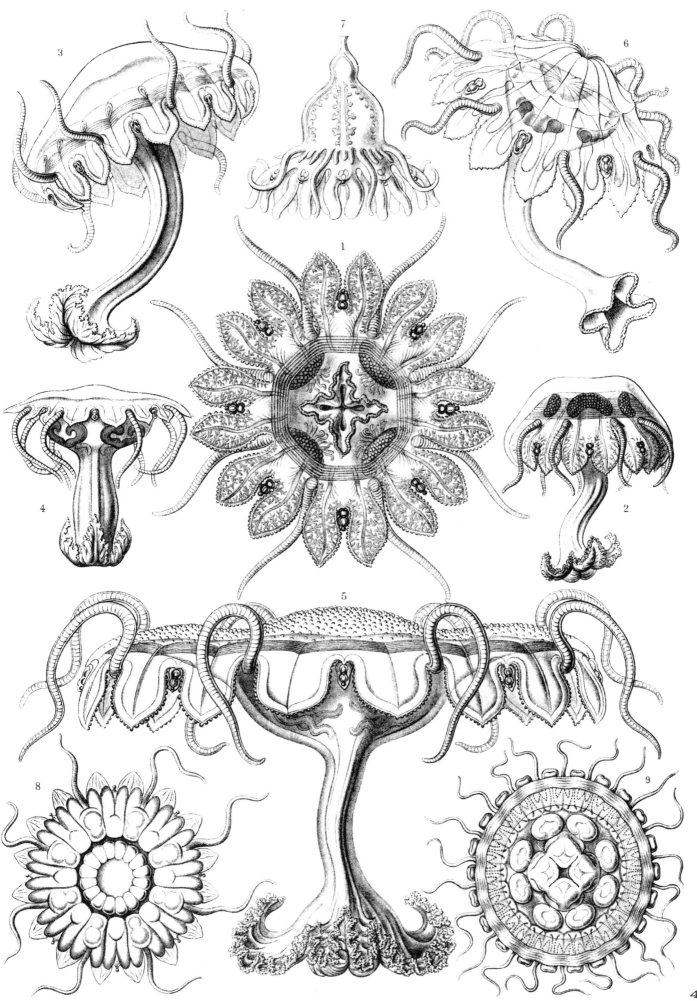

43

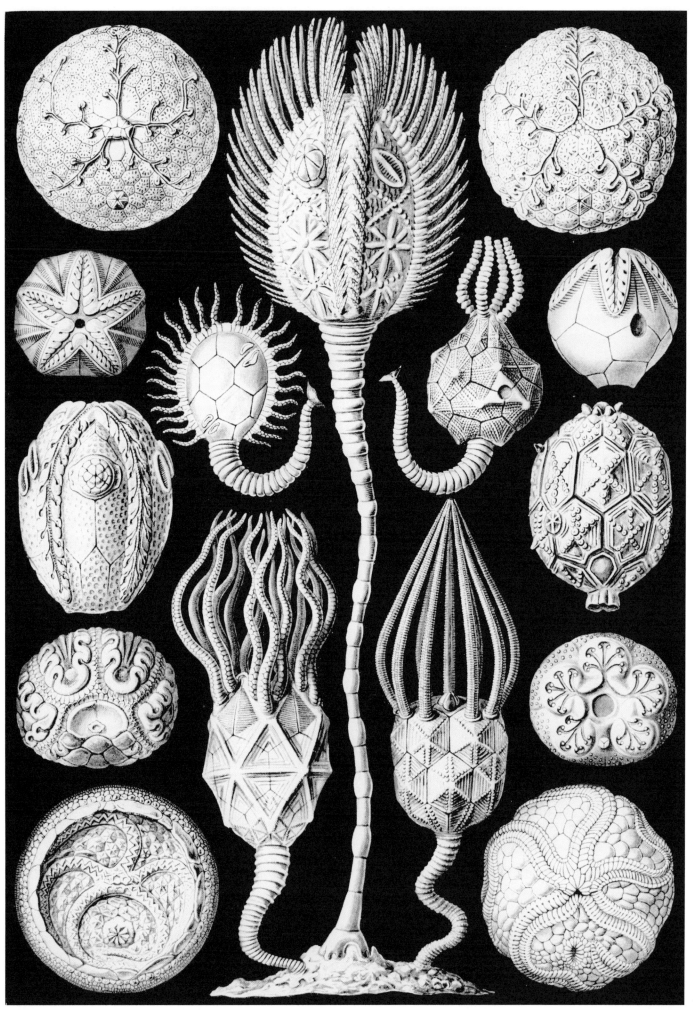

44

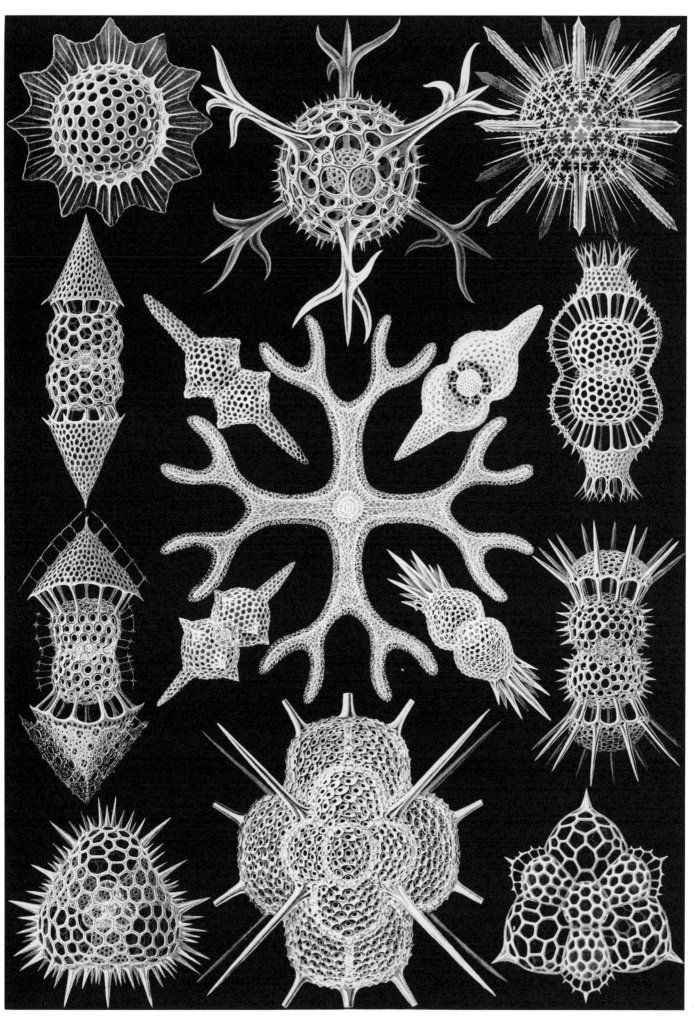

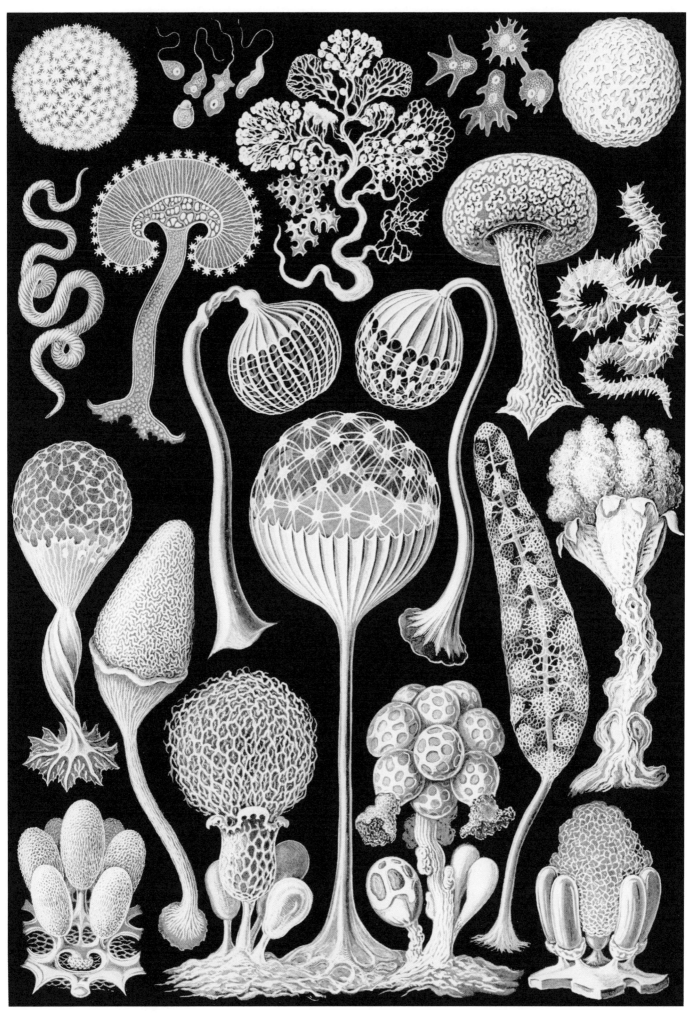

46

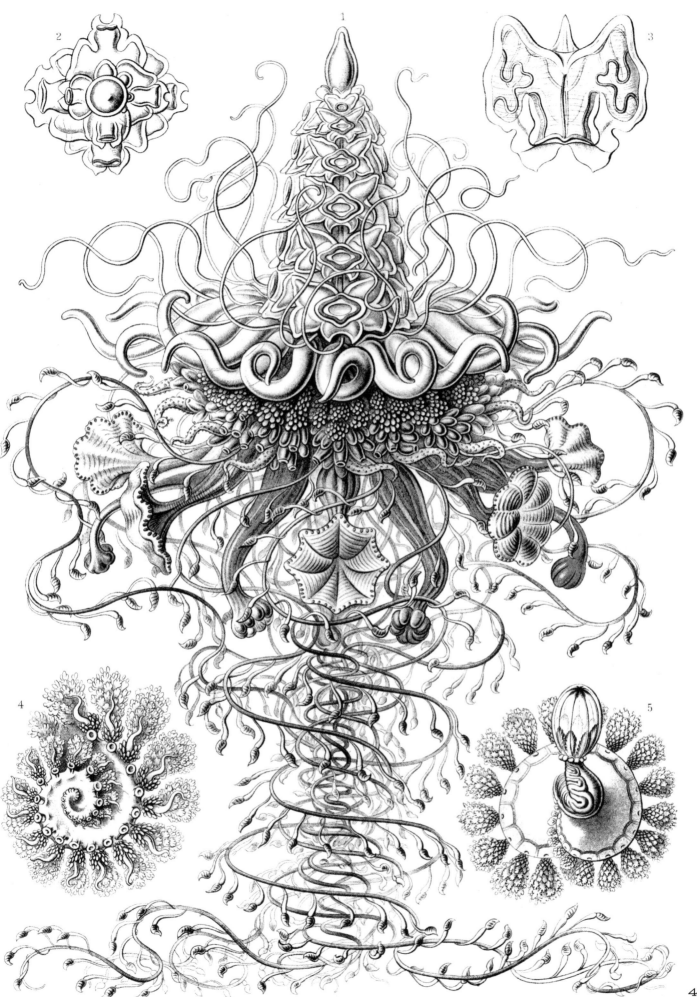

47

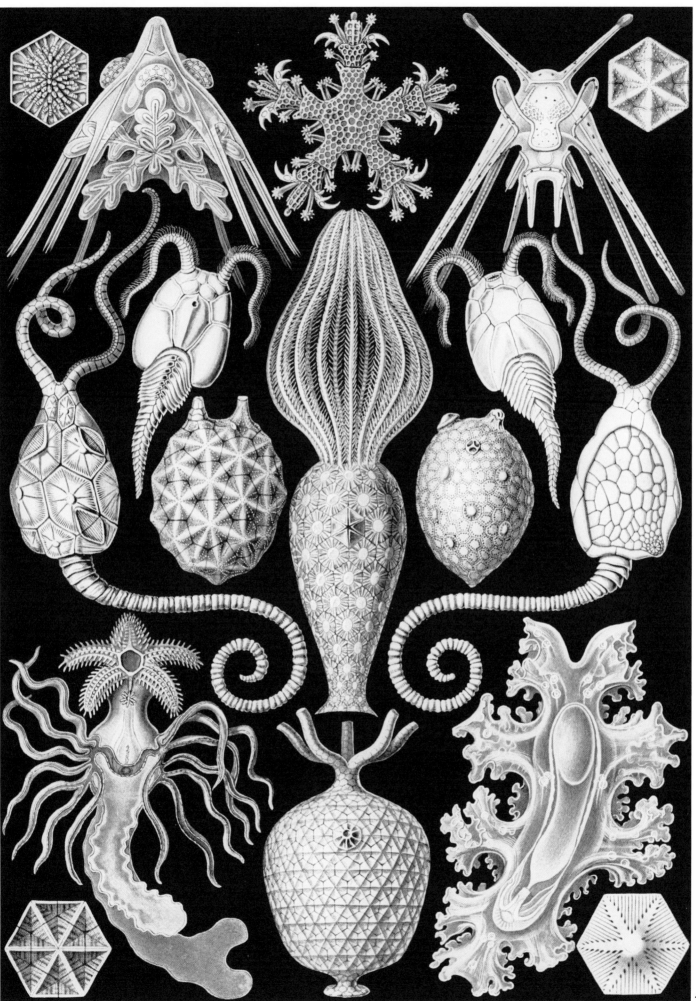

48

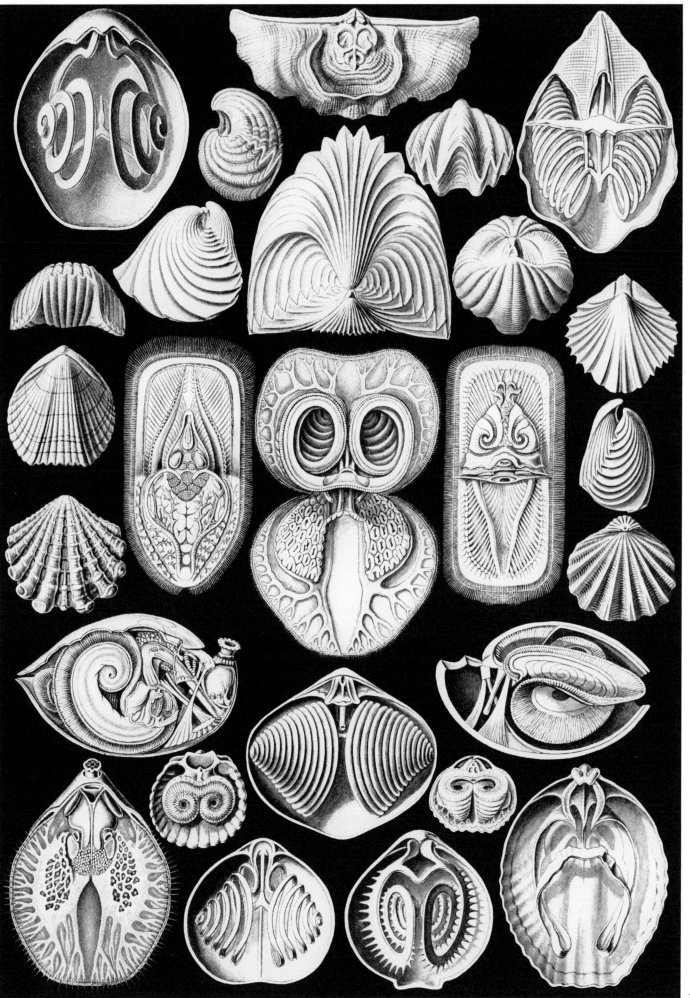

49

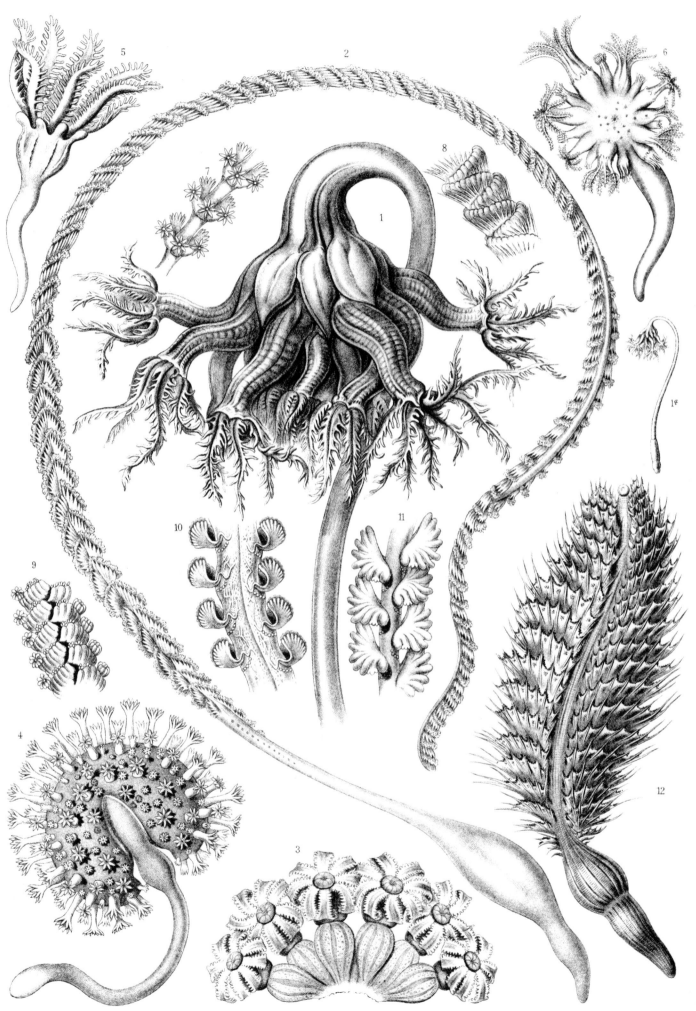

THOUGHTFULLY conceived and engagingly intricate, Pomegranate's coloring books combine stunning illustrations, high-quality paper, and sturdy construction to delight generations of coloring enthusiasts. With subjects ranging from fine art, nature, and architecture to history, the metaphysical, and more, Pomegranate coloring books offer something for everyone.

Visit www.pomegranate.com to see our full selection.

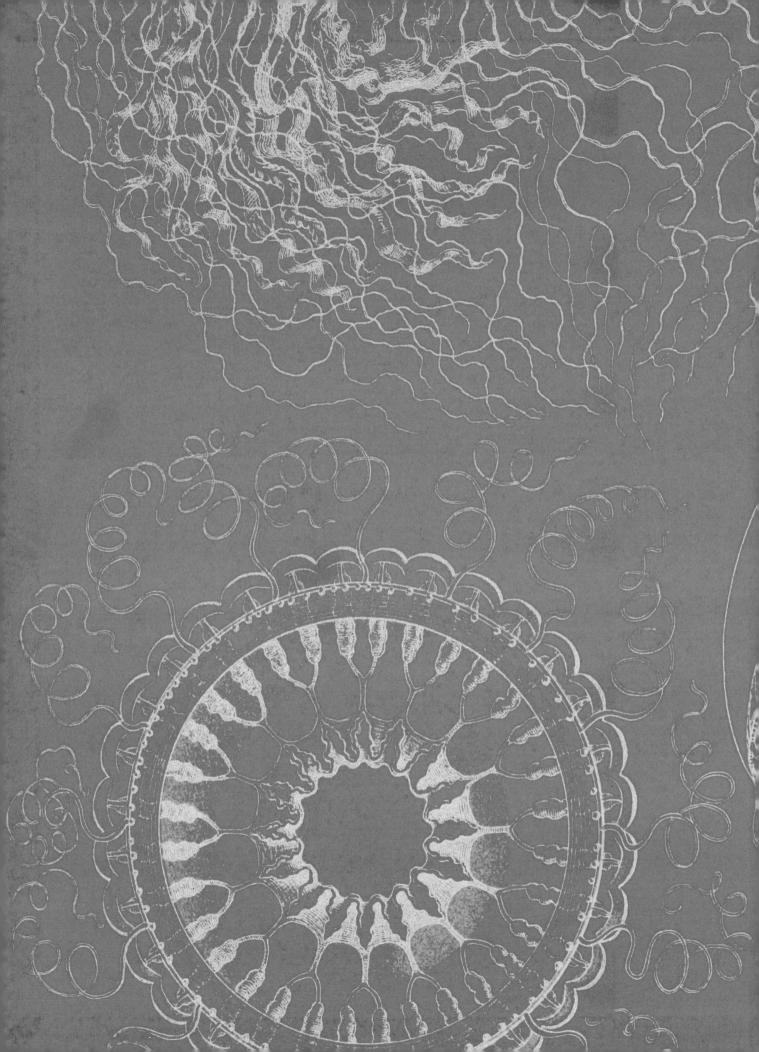